SAA

The society for all artists

101

TOP TECHNIQUES FOR ARTISTS

Step-by-step art projects from over a hundred international artists

David and Charles

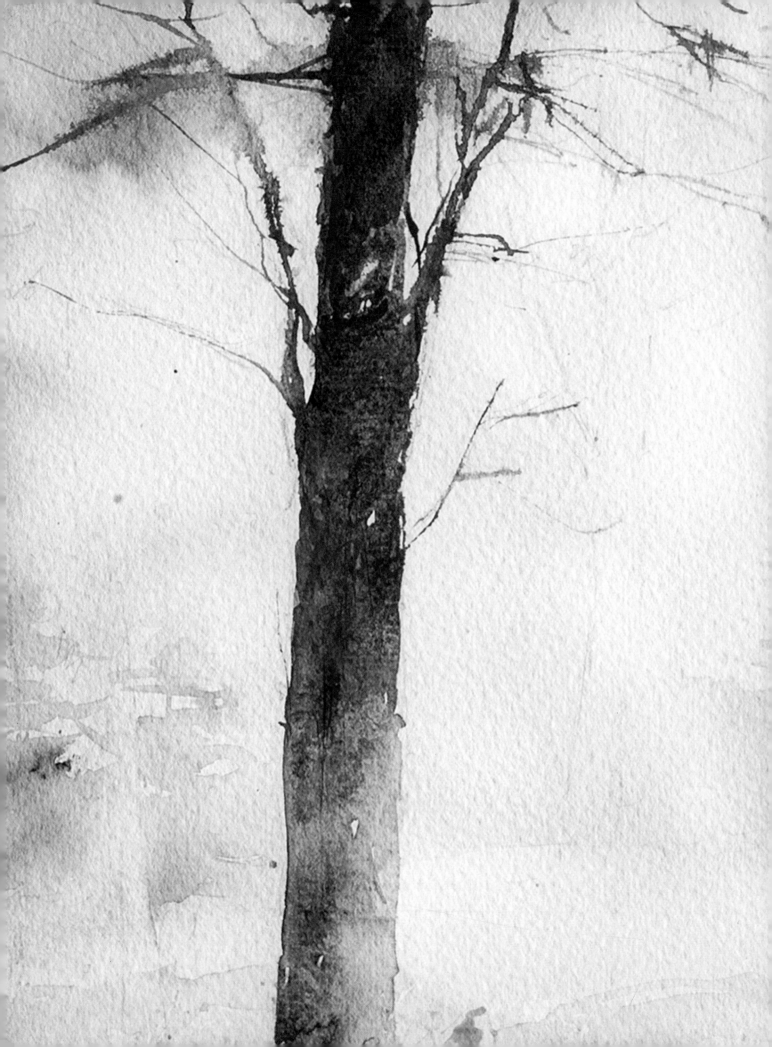

Contents

Introduction

Welcome to *101 Top Techniques for Artists*, brought to you in association with the SAA, the Society for All Artists

How do you paint realistic clouds? What is the best way to capture a crashing wave on a beach? How do you draw animal fur? Which colours do you use for realistic skin tones?

You will find the answer to these questions and many more in this colourful compendium, packed full of practical tips and techniques by 101 of today's most popular leading artists.

Each technique is presented in clear, simple step-by-step instructions that describe how to complete the project yourself, including a full list of materials and detailed images to guide you along the way.

Bursting with artistic inspiration...

Divided into seven chapters that cover watercolours, acrylics, oils, pastels, drawing and mixed media, this handy book is bursting with some of the most popular styles and subjects, designed to showcase the very best of artistic abilities available to help develop your own creative streak.

It includes handy hints from inspirational artists such as: Marilyn Allis, Vic Bearcroft, Malcolm Cudmore, Keith Fenwick, Jeremy Ford, Sharon Hurst, David Hyde, Geoff Kersey, Roy Lang, Matthew Palmer, Fraser Scarfe and many, many more.

Whether you're a beginner or a more experienced artist, there's something new to learn for everyone in this comprehensive collection.

Unlock your creativity with the SAA

All contributors featured in this book are professional artists belonging to the SAA, who together with a global community of over 46,000 other members, make up the world's largest and friendliest art society.

Whether you're a beginner, an improver or a professional, discover how we can encourage and inspire you to try something new.

To explore the colourful world of the SAA, visit us at *saa.co.uk* or call **0800 980 1123** and find out how we can help you network with thousands of other like-minded artists to unlock your creative passion.

Animals & Wildlife

Painting animals with vibrant backgrounds

Alison Board

Natural forms and wildlife are my main source of inspiration and textures are essential to creating them. Mixing media together can be unpredictable, yet it helps to provide the work with a variety of layers. Here the intention is to make the background just as important as the focus of the painting and to bring all the elements together.

YOU WILL NEED:

Artists' watercolours: cobalt blue; cobalt violet; lamp black; Prussian blue; green gold

Calligraphy ink: black

Pencils/pens: waterproof sketching pen; fine brush or ruling pen

Brushes: Kolinsky Size 12 round sable; bristle brush for gluing

Paper/support: 425gsm (200lb) NOT (CP) watercolour

Other: multi-purpose glue; plastic pot for mixing glue with water; tissue paper or thin fabric scraps; small piece of firm card or cut-up credit card; white acrylic gesso; masking fluid and applicator; spray bottle

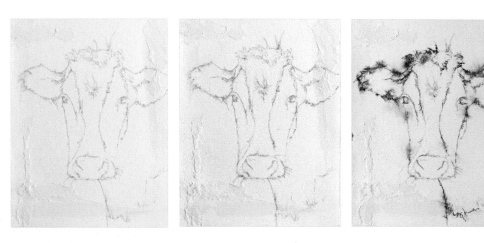

1. Sketch out your subject then combine a variety of textures, for example tissue paper and thin fabrics, to assemble your background. Glue the textures firmly with a brush and strong, white glue that dries clear, mixed half-and-half with water.

2. When the glue is completely dry, use a firm piece of card or an old credit card to scrape a thin layer of acrylic gesso primer over the edges of the textures into the background; depending on your subject matter, use the gesso to add texture there, too. Apply masking fluid to create tufts of fur around the ears, muzzle and head, preserving the white of the paper underneath.

3. To increase the dynamism of your textures and help them cross the boundary into background, apply a little water-soluble calligraphy ink with a fine brush or ruling pen. When almost dry, spray sparingly with water and allow it to spread. Tighten up your drawing at this point with the waterproof sketching pen.

4. Using the large brush, apply watercolour to your piece, starting with the background and finishing with your main subject matter. Be adventurous with your choice of colours but maintain a limited palette so that the colours stay fresh. Finally, remove the masking fluid.

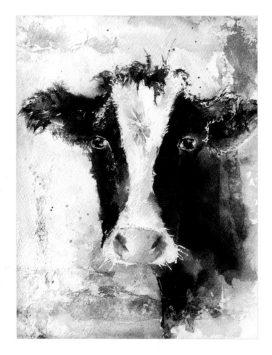

Artist's Tip

The artist has used Winsor & Newton calligraphy ink, Pitt artists' waterproof sketching pen, SAA brushes, Saunders Waterford high white watercolour paper and Elmer's glue-all.

Using pastel pencils for animal portraiture

Colin Bradley

I started using pastel pencils about 30 years ago and although I have painted many subjects, it is animal portraiture that works best with this medium. The pastel pencils create a glassy animal eye and the look of realistic fur or hair; they can also be sharpened to a fine point for incredible detail and easily erased should the need arise.

YOU WILL NEED:

Pastel pencils: white 101; ivory 103; burnt ochre 187; brown ochre 182; burnt sienna 283; Payne's grey 181; light flesh 132; warm grey IV 273; Van Dyke brown 176; Indian red 192; Venetian red 190; black 199

Paper/support: 160gsm (98lb) sand-coloured pastel

Other: No. 2 grey-tipped chisel-end colour shaper or paper blender

Artist's Tip

The artist has used Faber-Castell pastel pencils and Fabriano Ingres pastel paper.

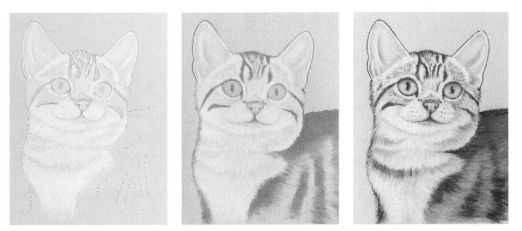

1. Start by boldly applying white to all the areas of dominant white fur then apply ivory highlights in the eye. Apply a lighter white as a base for the stronger colours then lightly use the warm grey on top of this weaker white base for the head and body.

2. Next apply light flesh to the ears, fur and nose. Apply a mid warm grey around the ears and to the stronger grey areas, lightly blending with the colour shaper to smooth the colour. Then apply brown ochre to the eyes, avoiding the white highlight.

3. Add mid warm grey to the ears, mouth and white fur then Payne's grey on top of the mid grey to darken the fur. Deepen the ochre colour in the eyes using dark brown, then strengthen the nose and the ears using Venetian red. Lightly blend the dark fur using a blending tool.

4. Deepen the dark areas using the black pastel pencil. Use a little Van Dyke brown and burnt sienna in the eyes, then Venetian red and Indian red to bring colour to the nose. To complete, blend ivory, brown ochre and Venetian red into the background then use a sharp white and Payne's grey to draw in the whiskers.

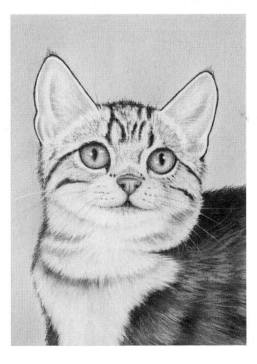

Depicting animals with fur

Catherine Inglis

Pastel is the ideal medium for depicting animals with fur. Build up multiple pastel layers on sand-grain paper to achieve great depth comparable to an oil painting; the dark background used here contrasted well with the subject, Dixie. By paying attention to the tonal values and carefully selecting the colours, a wonderful painting can be completed.

YOU WILL NEED:

Conté hard pastels: black sketching 2B; portrait brown 2464; pink 11; pink 49; brown 17; brown 23; brown 31; brown 32; brown 42; brown 52; brown 54

Sennelier soft pastels: bronze green deep 155; burnt sienna 456; burnt sienna 457; purplish blue grey 478

Unison soft pastels: grey GR27; brown earths in various creams & browns (some are brown earth BE07, BE08, BE09, BE11 & BE12); for the background use additional colours A37 & A43; yellow green earth YGE18; pale purple/greys and sepias for cool shadows in fur (some are grey GR10, GR11 & GR17); lights and brights – blues, purples, lilacs and pinks for highlighting (some are light set LS07, LS08, LS10, LS11, LS13 & LS14)

Pastel pencil: white

Paper/support: 800 grade dark grey sanded

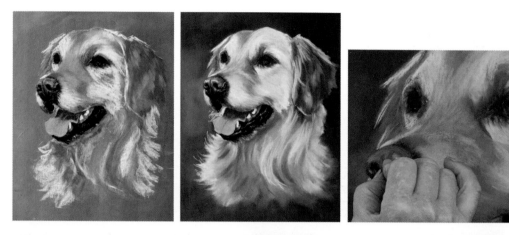

1. Draw the outline of the subject using the white pastel pencil. Paying attention to the tonal values, use the hard pastels to apply light sidestrokes that follow the contours of the face and direction of fur, blending as needed to soften the texture. Then block in the eyes, nose and mouth, avoiding any further definition at this stage.

2. Now using the Unison soft pastels, block in the background. Then apply more detail to the fur, layering lighter tones over the darker underpainting, especially for the long fur of the neck and ears, blending as required. Work the tongue shadow using Sennelier 478 then work in warm pinks for lighter tones.

3. Use warm pinks and browns to bring texture and colour to the nose then use Sennelier 478 to create the underside shadow, pinks to create delicate highlights, and grey 27 as the highlight at the nose tip. Work the jaw shadows with Sennelier 478 as well as mid blues and purples then highlight them using grey, not white. For the gums, apply cool midtone pinks.

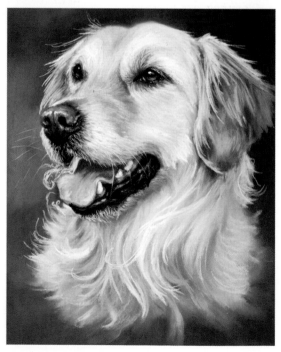

4. Graduate the shadow of the iris under the eyelid with Sennelier colours 155, 456, 457 and Unison soft BE11, creating a warm glow at the bottom of the iris. Use Grey 27 for the catch of light near the pupil and add touches of mid/pale blue to create the wet look on the bottom lid. To complete, finish the highlights on the fur, highlight the tongue, and use Conté pastel to apply the whiskers.

Using watercolours on synthetic waterproof paper

Howard Jones

The inspiration for this painting came from a visit to my local fishmonger. I felt that the iridescent colours of the mackerel could be shown off perfectly by the use of watercolours on synthetic waterproof paper.

YOU WILL NEED:

Artists' watercolours: phthalo blue; viridian green; cadmium orange; aureolin

Water-soluble pencil: red

Brushes: No. 6 round sable; large soft mop

Paper/support: approximately 30.5 x 46cm (12 x 18in) synthetic waterproof paper,

Other: hairdryer; spray mist bottle; 7.5cm (3in) clean foam roller

1. Using the red water-soluble pencil, draw the mackerel centrally on the paper. Mix phthalo blue and viridian green then brush this into the background and around the mackerel with the soft mop brush. Speed dry these colours with a hairdryer; the result will be a marbled effect.

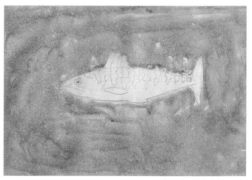

2. Next spray the entire paper with water from a height of 60 to 90cm (2 to 3ft); start spraying with the bottle held away from the painting, so that the first heavier droplets do not fall on it. Wait two minutes then use the roller to start rolling the surface to a smooth finish.

Artist's Tip

The artist has used Yupo synthetic waterproof paper.

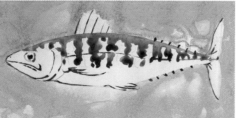

3. Using the No. 6 round brush, start to paint patterns on the back of the fish with viridian green and phthalo blue, alternating the colour each time you reload the brush – don't be mean with the paint. Then use the point of the brush to outline the fins, gills, mouth, body, eye and pupil.

4. Drop cadmium orange and aureolin into the eye and gills then aureolin into the fins and some of the back patterns. To complete, use the No. 6 round brush with a mix of phthalo blue and viridian green to spatter the painting in a diagonal direction.

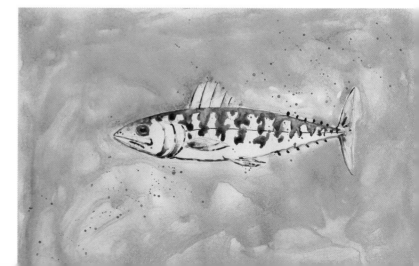

Layering acrylics to build texture in fur

David Hyde

Here I will be painting fur, but this technique can be used for feathers and many other textures. Any traditional acrylic paint can be used, but I prefer Soft Body Liquitex; it has a more fluid consistency than normal paint and retains its colour strength better when diluted. I do use some Heavy Body paint, as there are more options in this range. All layers, apart from the final stage, are applied in thin coats, allowing each layer to dry before proceeding with the next.

YOU WILL NEED:

Acrylics: transparent raw sienna; Turners yellow; transparent burnt sienna; burnt umber; French ultramarine; titanium white

Brushes: medium size round; small round; large flat

Other: gesso; thin MDF board; sandpaper; rubber brayer

Artist's Tip

The artist has used Liquitex Soft Body acrylic paint, Winsor & Newton Galeria brushes and Liquitex gesso.

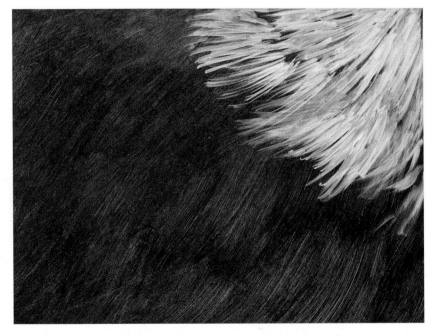

1. Use a roller to apply several coats of gesso to a piece of thin MDF board, ensuring it is applied evenly to achieve consistent opacity, and sanding between each coat. Next underpaint a dark mix of French ultramarine and burnt umber, taking care not to apply this too thickly as ridges will mar any later detail. Allow this to dry thoroughly then lightly sand. Start the texturing process shown at top right with a milky mix of opaque white, leaving gaps to reveal areas of underpainting.

2. Once the first layer of texture is completed and dry it will appear greyish. Now repeat this stage by applying a second layer, avoiding the exact marks made in the previous one. This semi-transparent overlay will start to build softness, texture and opacity, so repeat the process until you are satisfied with the result – this can be time-consuming.

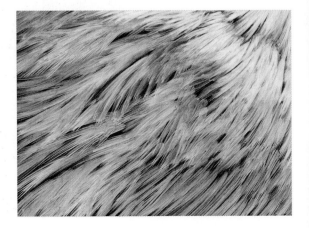

3. Mix separate glazes of transparent or semi-transparent paint; here burnt sienna, burnt umber, raw sienna and French ultramarine have been used. Apply the colours freely with a flat brush, blending them together as you do so. Allow these to dry then mix further glazes of dark colour to introduce shadows and depth, noticing how your texture remains visible through the paint.

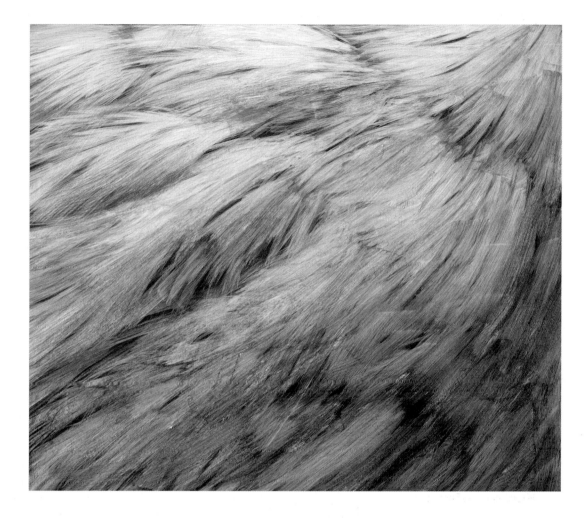

4. Build up colour and detail using opaque paint mixed with white. Make your texture appear more three-dimensional by contrasting lighter colours at the tips and edges of upper layers with the darker layers below. Add light and highlights where appropriate and finish by adding fine detail using your smallest brushes.

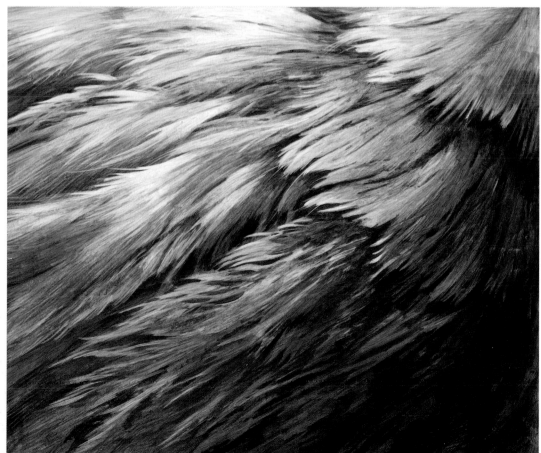

Drawing animal fur in monochrome

Lee Hammond

Hair is made of hundreds of thousands of hair strands; it is thick and voluminous, with many layers. Study the head or curls, and you will see that the light bounces off the surface of the hair in large areas. It takes hundreds of pencil strokes and much blending to white paper to recreate this look.

YOU WILL NEED:

Pencils/pens: 0.5mm mechanical pencil; 2B pencil

Paper/support: 27.9 x 35.6cm (11 x 14in) smooth Bristol

Other: blending stumps and tortillons; kneaded eraser; ruler

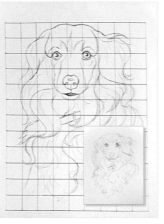

1. Lightly draw a grid of squares on your paper with the mechanical pencil and ruler; the sides of each grid square should measure 2.5cm (1in). Now accurately draw the shapes you see within each square with the 2B pencil, working one square at a time. When the shapes are correct, remove the grid lines with your kneaded eraser.

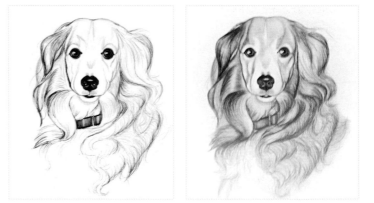

2. Still with the 2B pencil, begin working on the eyes, drawing the black pupil with a lighter iris. Blend this with a stump then lift out a highlight with the eraser. Add darkness around the eye, the nose, the mouth and collar, continuing to blend then lift highlights with the eraser. Now start to create fur in layers, applying pencil strokes in the direction the hair is growing.

3. Using a stump, next blend out all the pencil lines you have applied to various smooth shades of grey. Leave the white of the paper to show in the face area, around the eyes, the muzzle and the chin. Continue adding layers of pencil lines to deepen the tones of the dog's fur.

4. Create curls with dark, medium and light tones, lifting out highlights to make the curls look shiny. Blend a light grey in the chest area, adding light, curly pencil lines and using the eraser to lift the lighter curls. Finally, create lines for the short fur on the head with rapid strokes, blending it smooth.

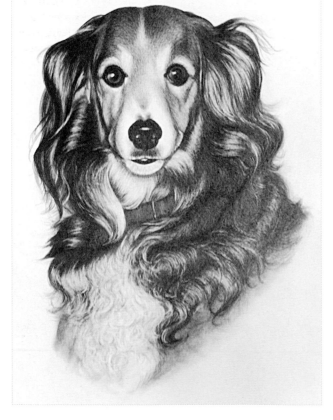

Painting a duckling wet-in-wet

Louise Bougourd

My favourite watercolour technique is wet-in-wet; I just love the way pigment moves on the support, infusing with other colours to create the most amazing effects. You need to have a little patience, allowing the paint to meander and blend, and resisting the temptation to interfere. This duckling sparked my imagination – I knew immediately that wet-in-wet would be ideal for this painting. Enjoy yourself having a go!

YOU WILL NEED:

Watercolours: aureolin; burnt umber; French ultramarine

Pencils/pens: pencil

Brushes: Size 10 round sable; Size 4 rigger

Paper/support: 300gsm (140lb) traditional white

Other: two water pots; kitchen towel

Artist's Tip

The artist has used SAA brushes and suggests using either Saunders Waterford or Fabriano Artistico watercolour paper.

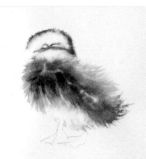

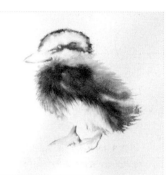

1. With your pencil, make a light sketch of the duckling then wash water over it, allowing this to settle until no longer shiny. Next mix aureolin and clean water in your palette to create a fairly loose yellow wash and apply this with the round brush, painting near the edge of the wetted area so the colour gently merges into the previously wetted edges – this creates a soft, feather-like appearance.

2. Now mix burnt umber and French ultramarine to create a dark grey-brown of thick consistency. While the aureolin is still damp, add small amounts of dark mix with your rigger and a flicking motion to suggest the dark feathers on the head, wings and body. Leave to dry.

3. Dampen the legs and feet then apply aureolin to them, remembering where the light is coming from. Add a light shadow to the side of the legs using the dark mix. Dampen the beak then add a mix of aureolin and your dark colour to achieve an effective result.

4. Using your dark mix and the rigger, paint the eye, leaving a white area to add sparkle. Finally with your rigger, wash water along the base of the duckling's feet, adding both aureolin and your dark mix to suggest the ground.

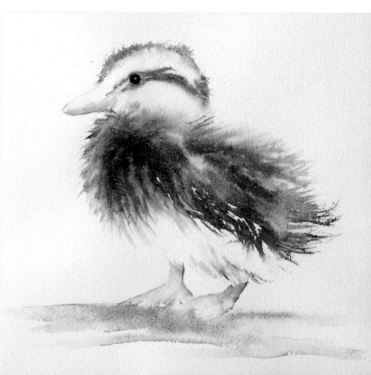

Establishing the best white for a task

Linda Kemp

White has a multitude of uses: it can be used to lighten the value of a colour; to prime a canvas; to block out; to create semi-transparent glazes; or to establish white passages. With the variety of whites on the shelves at the art supply store, it can be difficult to know which is the best choice for a particular task, but follow this easy technique to find out.

YOU WILL NEED:

Acrylics: titanium white; zinc white; yellow ochre; violet; phthalo blue; cadmium red medium; gold; cobalt blue

Brushes: ½in flat; 1in soft flat

Paper/support: canvas

Other: gesso; magic marker; ruler

1. Zinc white was applied over five test areas. The results show that it is excellent for glazing and creating semi-transparent layers, but is poor when covering colour or lines. Transparent colour becomes semi-transparent when mixed with it and remains smooth in heavy applications.

2. Titanium white was applied over the five test areas. The results show that titanium white is all-purpose and versatile, with a strong influence when mixed. It is moderately opaque, flexible, and can be applied in thick layers without cracking.

3. Gesso was applied over the five test areas. The results show that it is extremely opaque, excellent for blocking or covering colours and lines. It is best for priming and is semi-absorbent; it also has a strong influence when used to lighten – a little goes a long way.

4. In this acrylic painting completed on 30.5 x 30.5cm (12 x 12in) clay board, I actually used three different whites: opaque gesso to block out darks for the small negative spaces between the branches and leaves; titanium white blended with cobalt blue to lighten and for glazing; and zinc white, generously brushed over the lower half of the piece then sprinkled with water, to create textural marks for a frosty veil of mystery.

Capturing the simplicity of form

Monika Cilmi

I found real inspiration in this technique because it is based on simplicity and the always-valuable statement 'less is more'. I find it very useful to help see things in a different perspective and to capture the essence of form. This exercise should provide you with the opportunity to learn a precise but free technique, keeping an open mind and improving your visual and imaginative skills.

YOU WILL NEED:

Chinese or Japanese liquid ink: black

Brushes: Chinese or Japanese medium brush

Paper/support: rice paper

Other: paperweight

1. Set up your workspace, firmly securing your paper in position with a paperweight. Start by drawing a slightly curved stroke from right to left. Opposite this, draw a short curved line and a longer one, ensuring that the latter joins with the left-hand line at its base.

2. Next add the eyes, one of which slightly protrudes on the other side of the fish's head. Draw two thin lines in the middle at the top to represent the mouth, adding two short lines either side of it. Then work on the tail with large strokes, releasing the brush quickly.

3. Draw a long thin line in the middle of the body as a base for the dorsal fin. Now add the fins to each side by drawing two large ones at the front then two smaller ones behind with a similar application technique to that used for the tail.

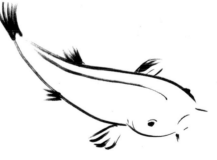

4. Complete the work by adding in the details. Build up the dorsal fin by applying bold, quick strokes from the base line as you did for the tail. To finish, add crosshatched lines on the body to represent the fish's scales.

Using inks to free up your style

Marilyn Allis

This project developed accidentally. I was given some acrylic inks and they sat in my studio for a long time. My students were being very constrained and precise, so I wanted to move them away from using pens or small brushes. If you were to squeeze the ink from the glass dropper, I imagined you would be unable to be fiddly – hence this technique was born.

YOU WILL NEED:

Artists' watercolours: quinacridone magenta; French ultramarine; intense violet

Acrylic inks: Prussian blue; purple lake; white; scarlet

Brushes: Silver Whopper Size 30 round

Paper/support: watercolour rough ½ imperial

Artist's Tip

The artist has used SAA artists' watercolours, FW inks, an SAA brush and Saunders Waterford watercolour paper.

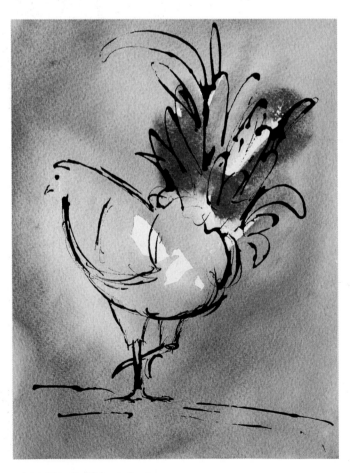

1. Using the brush and water, wet the paper with the exception of a few highlight areas. With first French ultramarine and then intense violet, quickly paint the rough shapes of the rooster to look like a watermark. Then add a wash of quinacridone magenta to cover the whole background.

2. Next take the Prussian blue and purple lake inks. Squeeze the ink up into the dropper by holding it in the bottle then gently squeezing on the rubber top until the ink fills the tube. Then start to mark the outline of your rooster, working first in blue and then in purple.

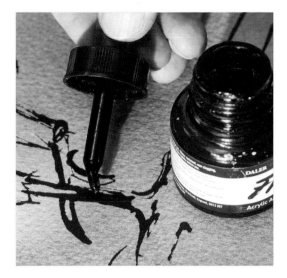

3. Continue to draw the outline of your rooster, squeezing the ink slowly onto the paper and correcting your marks as you need to. Any errors will only add to the movement and create further interest, so don't worry if you don't get it exactly right first time. Also lightly draw the shadows.

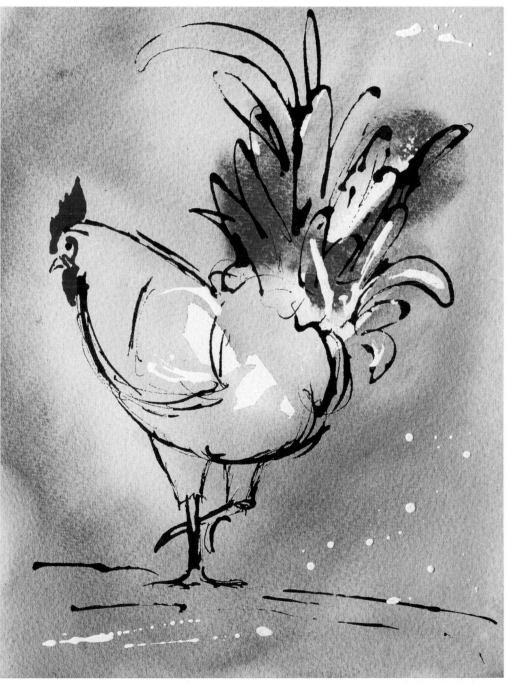

4. Once the inks have dried, use the red and white inks to add the red comb and any white highlights you lost with an over-enthusiastic wash. To balance the painting and create textural detail, add a little splatter of white to any bare corners.

Creating black fur in pastel

Vic Bearcroft

When is a black cat not a black cat? The answer is when it is bathed in sunlight. The coats of most black animals are not flat black, but rather dark shades of brown or blue-black. This is the colour you will most often see when sunlight shines through the coat. By using black velour paper, your colours will react against the black, giving the cat fur real vibrancy and depth.

YOU WILL NEED:

Hard pastels: black; white; mid-grey; yellow

Soft pastels: red-brown; sap green; orange

Paper/support: sheet of black velour

Other: white charcoal pencil or Tracedown in white

1. Using a white charcoal pencil or Tracedown in white, prepare your outline on the velour, followed by a monochrome sketch using the hard grey pastel. The sketch should not be too detailed at this stage; its purpose is to show basic form and shape using simple lines and tonal values.

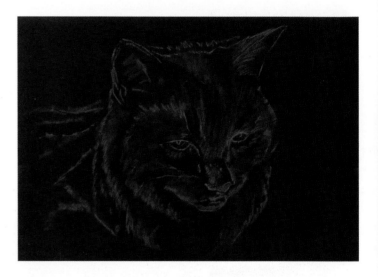

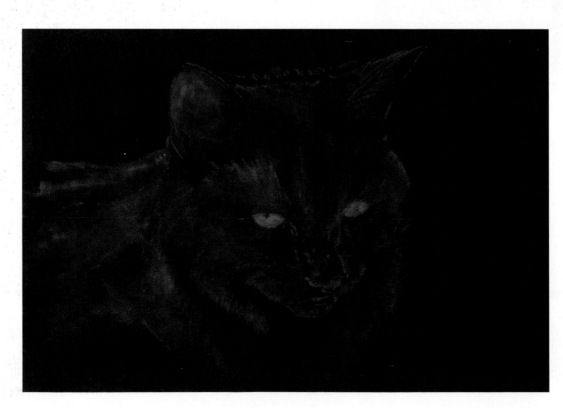

2. Using the soft pastels, block in the basic colours. Use the orange and red-brown for the warm, sunlit areas in the fur then sap green as a base coat for the eyes. Be bold and apply vivid colours that will react against the black velour, creating depth and vibrancy.

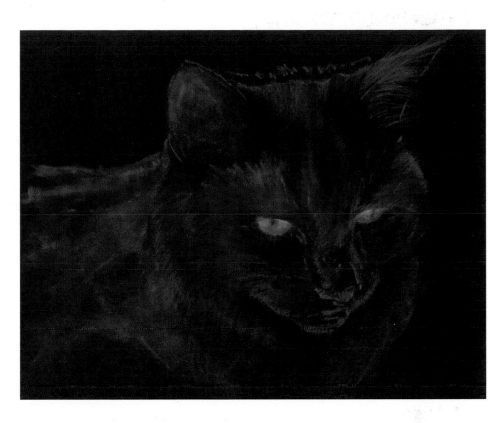

3. For the details, use the hard mid-grey pastel to create more fur texture, mainly in the mid-tone and shadow areas away from direct sunlight. You can make the fur as loose or detailed as you want. Use the hard yellow pastel to create subtle highlights in the eyes.

4. Re-establish lost darks with the hard black pastel, for example shadows in the fur and eyes, then use the soft red-brown pastel to pick up warm highlights around the edges. Finally, with the hard white pastel, create the eye reflections, whiskers and bright sunlit highlights around the top of the head and the nose.

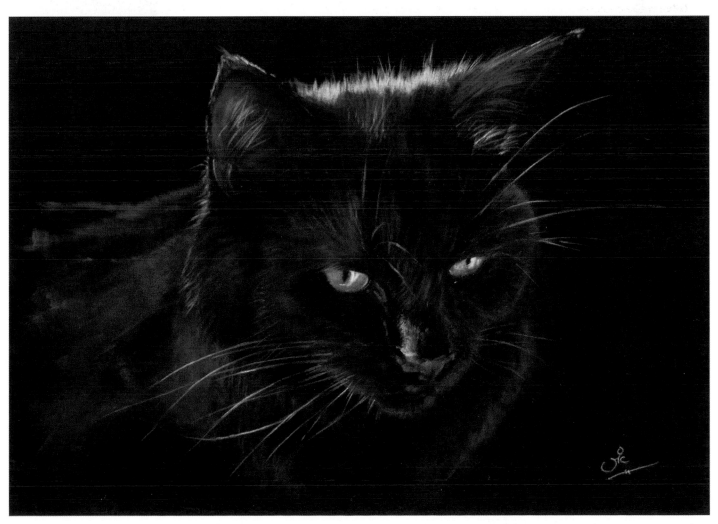

Painting an underwater effect with cling film

Sue Cartwright

Creating realistic and textured water is always a challenge. This effective technique uses cling film (plastic wrap) to bring an extra depth and quality to your work, especially when painting with watercolours wet-in-wet.

YOU WILL NEED:

Artists' watercolours: cadmium red; cadmium yellow; cobalt blue; indigo

Brushes: Kolinsky Nos 12 and 6 sables

Paper/support: 640gsm (300lb) NOT watercolour

Other: table salt; strips of cling film (plastic wrap)

1. Mix some cadmium yellow to a double cream consistency. Wet the three fish with the No. 6 brush and clean water. Work wet-in-wet to paint them with the cadmium yellow, applying the colours lightly on the top of each fish, and more darkly on the belly below.

2. Next apply a wash of cadmium red to each fish, again painting the underbelly more darkly. Lightly paint in the fins using cadmium red and whilst still wet, paint in the lines on the body, allowing them to blend slightly. Leave to dry. Add whiskers and lines into the fins, blending slightly to soften at the edges. Use dots of indigo to paint the eyes.

3. Mix cadmium yellow and cobalt blue to make a green. Liberally wet the paper avoiding the main body of the fish then apply cobalt blue and the green mix into the wet areas. Now quickly sprinkle the salt over the surface then scrunch up the strips of cling film (plastic wrap) and press these heavily onto the paper, including some areas of the fish so they will appear to be underwater and not floating on the top. Leave to dry.

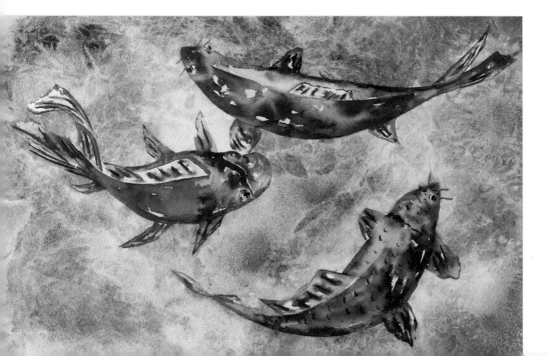

Artist's Tip

The artist has used Winsor & Newton artists' watercolours and Saunders Waterford watercolour paper.

4. When the cling film (plastic wrap) starts to stick to the paper, lift it off. Gently rub off the salt when it returns to its original colour.

People & Urban

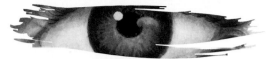

Painting a realistic eye

Cindy Agan

Painting realistic eyes is something many artists really struggle with. The eyes are one of the first things you notice in a portrait, and when painted well they can add great depth and character. This exercise will help you create realistic and captivating eyes, and you can apply the technique to painting animals, too.

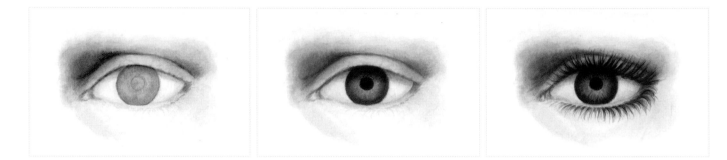

YOU WILL NEED:

Watercolours: Mars black; cerulean blue; ultramarine blue; Payne's grey; alizarin crimson; sepia; olive green

Gouache: white

Brushes: No. 4 round

Paper/support: medium weight watercolour

1. To provide the white of the eye with shape, first create a cast shadow under the lash line and in the corners with cerulean blue. When dry, use water to thin Mars black to grey and continue to develop these subtle shadows. Then wet the iris area and apply a mix of ultramarine blue and Mars black.

2. Next re-wet the iris and use Payne's grey to paint a dark ring around its outer edge, blending towards the centre. Once dry, use Mars black to paint a perfectly round pupil in the iris centre and deepen the shadow between the lash line and the top of the pupil.

3. Now paint the tear duct with alizarin crimson. Mix sepia and Mars black to paint the lashes following the direction of the hair growth. Make the lashes thicker on the outside edge; for the lower lashes, leave an area of flesh above the lash line. Darken some lashes with pure Mars black paint.

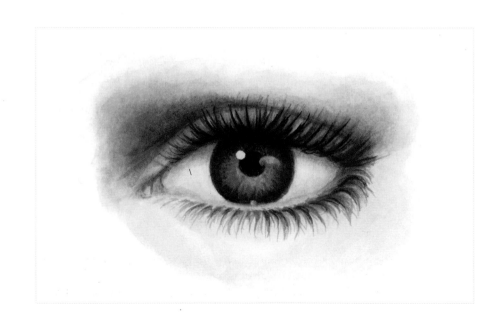

4. In the iris area, drop a touch of olive green in the lower left side then use white gouache to add a highlight on the left side, half overlapping the iris and the pupil. To finish, paint the highlights on the right and at the bottom of the eye with a mix of white gouache and cerulean blue.

Drawing realistic hands

Carole Massey

Including the hands in a portrait can add a very expressive element but they can prove quite a daunting subject and getting them wrong can mar the whole composition. Rather than avoiding the subject, be brave. Follow my simple steps to draw hands as much as possible, because we all know that practice makes perfect!

YOU WILL NEED:

Pencils/pens: Sharp 2B or 4B pencil

Paper/support: cartridge

Other: eraser

1. Working from a photograph, a model or your own hand as reference, start by drawing a curved line to represent the knuckles of the left hand and another for the angle of the wrist then complete this rough rectangular shape. Add the wrist and thumb base, as a flattened triangular plane.

2. Next draw the tapering rectangular shape from the knuckles to the first articulation, then the triangle running down to the tips of the fingers, which will curl underneath. Avoid the 'bunch of bananas' effect by initially assessing the fingers as a mass; later draw the negative shapes between each finger.

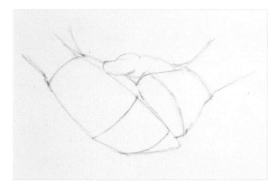

3. In this example not so much of the right hand can be seen, but follow the same steps, starting with the curve of the knuckles, the line of the wrist articulation, the wrist itself and the foreshortened triangular plane of the thumb base, and then the thumb itself.

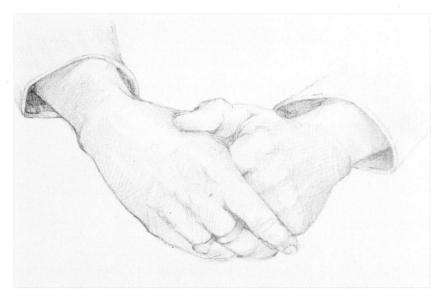

4. To complete, draw the lines or spaces between the fingers; rings, a watch or the cuffs, as shown here, can help add form, acting as contour lines around whatever shape they enclose. Finally, refine the drawing then add shading to provide the whole study with form and solidity.

Painting a portrait from a photograph

Gregory Wellman

Here is a practical method to help structure your portraits and stay in control. I've used acrylics, but this method will work for oils, too. By mapping your subject into zones, light and dark areas become more considered, giving you a realistic, characterful final portrait.

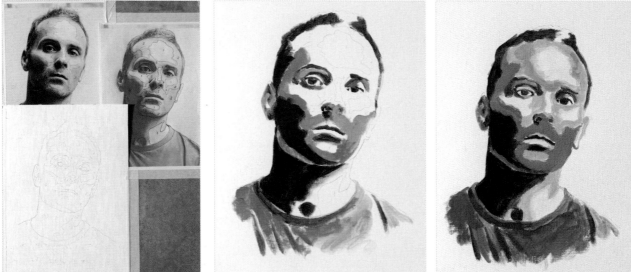

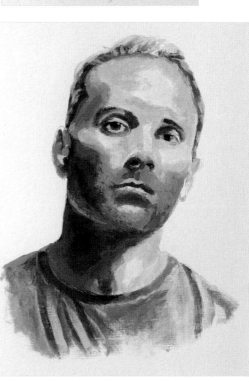

YOU WILL NEED:

Acrylics: titanium white; cadmium red medium; permanent rose; lemon yellow; yellow ochre; ultramarine blue; burnt umber

Brushes: No. 6 flat; No. 4 filbert; No. 4 round

Pencils/pens: pencil or pen

Paper/support: acrylic

Other: Tracedown; stay-wet palette

Artist's Tip

The artist has used Winsor & Newton artists' acrylics.

1. First produce a colour and a monochrome copy of the subject from your photograph, the same size as the final painting will be. The colour copy is for reference; on your monochrome copy, map and number zones of similar tone, limiting your zones to four. Transfer the image and zone mapping onto your acrylic paper using Tracedown.

2. Mix four colours as close to the four zones in the reference photograph as possible. Using the No. 6 flat, paint the darkest zone first, numbered 4 in the example, then zone 3. Take care with outlines, but you can paint more loosely where zones meet.

3. Paint the other two lighter zones in the same way, starting with the darker zone 2 then finishing with the lightest zone 1. Again, paint more loosely where the two zones meet.

4. Where zone 4 meets zone 3, use the filbert to combine the colours used for these zones to create a 'transition' colour, and paint it where the two zones meet; repeat this at each intersection. Continue to develop these transitions and introduce some blues into your mixes for cooler areas. Finally, with the round brush, carefully paint in some eye, nose and lip details.

Mixing realistic flesh tones

Mike Skidmore

Mixing realistic flesh tones efficiently and consistently is always a challenge. The Old Masters dealt with this by painting with similar flesh tones across their works, adding subtle colour variations and glazes over their base flesh mix for different complexions and lighting. In this project we'll explore how I do it.

YOU WILL NEED:

Oils: flesh tint; red; black; titanium white; cadmium red; yellow ochre; Payne's grey; raw umber

Paper/support: canvas

1. Start with a consistent base flesh mix, using flesh colour from the tube then adding red, black and titanium white in the quantities shown to ensure consistency and control the amount mixed. Mix plenty of your flesh colour, putting any spare mix in a jar and topping it with water to keep it wet.

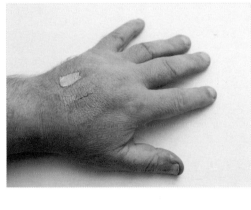

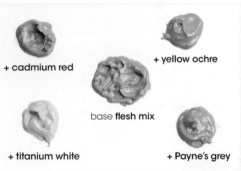

+ cadmium red | + yellow ochre

base flesh mix

+ titanium white | + Payne's grey

2. When working from a palette, other colours will usually surround your flesh colour, which can distort its appearance so it looks quite different when applied to the canvas. When women buy make-up, they check the colour by using their hand as a tester – so do the same here. Don't try for an absolute match; just ensure your colour looks 'fleshy'.

3. For a complete flesh palette, create variants from which to paint. Add to your base flesh mix titanium white for lightening, yellow ochre for a tanned look, cadmium red for warmth and Payne's grey for coolness; you might also add raw umber and cadmium red to darken the colour.

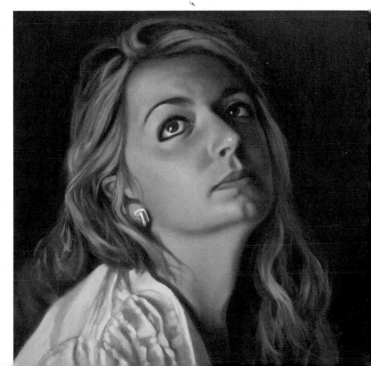

4. This portrait was painted using the base flesh mix shown. It was lightened with white around the eye, cooled with Payne's grey in the corner, and yellow ochre was added to the cheek. The flesh mix has been darkened with raw umber and red to paint the shadow areas.

Using light to create depth of shade

Irina Corduban

My inspiration for this painting comes from George de la Tour's work using the Chiaroscuro technique, which was developed during the Renaissance period. It is an easy way to express yourself with just a couple of lines, working only on the light side of your image, thereby letting the paper produce the maximum depth of shade.

YOU WILL NEED:

Acrylics: white; gold

Pencils/pens: soft pencil

Brushes: fine point

Paper/support: plain and black

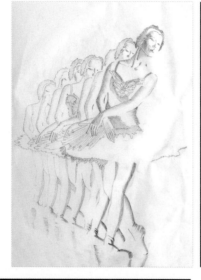

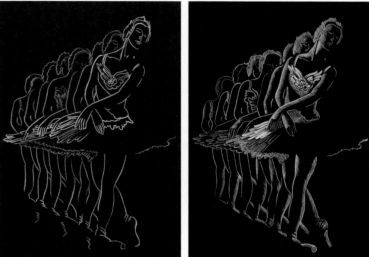

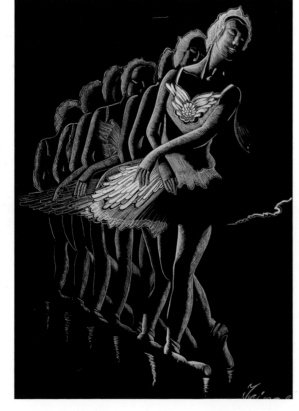

1. With your pencil, sketch the row of ballet dancers onto the plain paper. Pay particular attention to what will become the lighter side once the drawing is transferred to the black paper, bearing in mind that the black of the paper will become the shadow areas.

2. Now transfer your drawing onto the black paper. To do this, apply white paint to the back of your sketch then press this onto the black paper to leave marks. Then use the fine point brush to redraw the full shape in white acrylic.

3. Start to add white crosshatching with the fine point brush to pick out the lighter areas where the light falls on the subject, retaining the shadow areas as plain black paper.

4. To finish, add gold paint with the fine point brush between the layers of crosshatching to increase the three-dimensional impact of the piece.

Using objects as templates for portraiture

Paul Knight

Using the shapes of a mushroom and plant pot is a simple way to create both the basic proportions and shape of a face. Both are rounded objects, so if you concentrate on developing their form you will achieve a more three-dimensional character in your portrait. When studying subject matter, use this method to find other simple shapes that can be used as a template for your work.

YOU WILL NEED:

Tinted charcoal pencils: charcoal dark; white

Paper/supports: neutral grey pastel paper

Artist's Tip

The artist has used Derwent charcoal pencils and Derwent pastel paper.

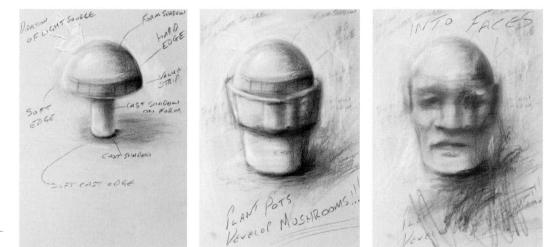

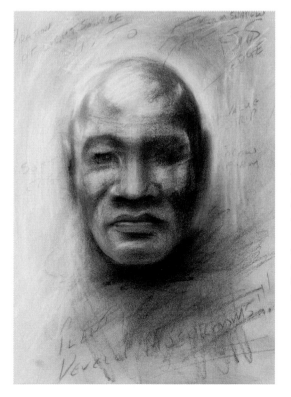

1. Start by drawing a loose outline of a mushroom with the base ot the stem reaching approximately halfway down your sheet of paper. Then use both your charcoal pencils to introduce a three-dimensional appearance to the mushroom by applying highlights and shadows to either side.

2. Draw a simple plant pot beneath, making the sides slightly wider than the mushroom. At the base of the mushroom stem create a second tier to the pot, narrowing the lower half as it tapers down. As your draw this stage, again introduce three-dimensional elements by applying areas of light and shadow.

3. By developing the mushroom and plant pot using light and shadow to develop a three-dimensional form, you have created the perfect template for a face. Now develop its main features – the nose, eyes and mouth – continuing to build the light and shaded areas.

4. Together, the elements build good points of reference from which to work, and allow you to develop the face into a realistic likeness. Try this project again from Step 2, this time incorporating the features from a photo reference or a sitter to develop good life drawing skills.

Capturing a dynamic moving figure

Rebecca de Mendonça

To capture moving figures successfully you need to apply your marks with energy and variety – this will bring life and vigour to your picture. As you work, it helps to imagine what it would actually feel like to be that moving figure.

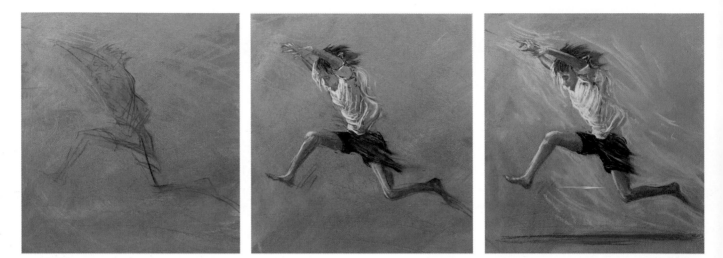

YOU WILL NEED:

Unison pastels: blue green 3; dark 18; grey 28; orange 12; special collection 3; red earth 9; orange 8; blue violet 9; blue green 5; blue violet 1; blue violet 2; blue violet 15

SAA artists' soft pastels: French ultramarine 5; burnt umber 5

Conté crayon: red; burnt sienna

Paper/support: terracotta pastels

1. First use the red Conté crayon to sketch out your figure's dynamic pose, thinking about the direction of movement and the diagonal composition. With blue green 3 pastel, base in the sky with vigorous sidestrokes, thinking about the figure flying past and twisting the pastel around it in places.

2. Using burnt sienna Conté crayon for the skin then cream and blue pastels for the fabrics and hair, define the figure more. However don't just outline it: use hard edges to describe the structure, and softened edges to indicate the flow of movement behind. Allow the colours to overlap and combine loosely in some areas.

3. For the flesh tones, hatch different pastel colours to describe muscle form. For the hair, break dark blues and browns into smaller pieces with sharp edges then use them to make little flicks and twists, imagining the wind blowing through the hair and fabrics. Add more blues to the sky and shirt.

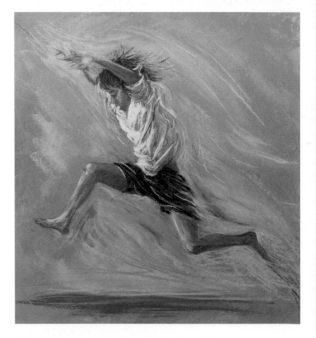

4. Finally to emphasize the motion, strengthen some lines, introducing bright colour flashes and linking one area to another to create a sense of flow and direction. Soften the edges in places, add energy marks to the sky and strengthen the brighter front edge of the body. Don't overwork the looseness.

Creating mood in a street scene

Sean Terrington Wright

Capturing the mood of this street scene revolves around two key elements. First, you need to establish a wide, dramatic range of tonal contrast, from light to dark, to achieve counterchange. Second, create impact by placing large and small shapes then warm and cool colours next to one another, reducing many elements to subtle silhouettes.

YOU WILL NEED:

Artists' watercolours:
French ultramarine; Payne's grey; raw sienna; alizarin crimson; cadmium orange; burnt umber; opaque white; viridian hue

Brushes: large mop; No. 12 round

Paper/support:
300gsm (140lb) rough watercolour

Other: spray bottle; kitchen towel or tissue

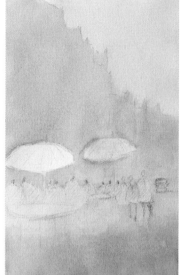
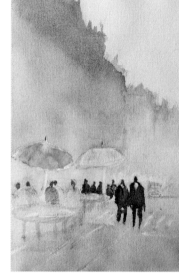
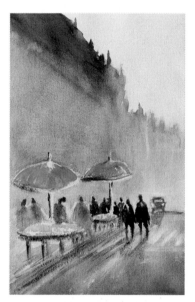

Artist's Tip

The artist has used SAA artists' watercolours and Arches watercolour paper.

1. Mix French ultramarine, raw sienna, and alizarin crimson into a weak, watery liquid. Use this mix and the large mop to paint the sky and foreground, working from the top of the paper to the bottom. Strengthen the mix with the same three colours then paint the buildings and foreground.

2. Next with the round brush, underpaint the rooftops using a mix of Payne's grey and French ultramarine. Keep the buildings moist by spraying them with water then lift out paint near the horizon with the kitchen towel or tissue. Indicate the tables and paint the figures with their umbrellas using French ultramarine, cadmium orange and Payne's grey.

3. Paint a stronger Payne's grey on the left-hand rooftops, running in clear water so that colour runs below the roof. Now paint stronger mixes of cadmium orange and French ultramarine over the seated figures, tables and umbrellas. Use burnt umber and a drybrush technique to paint directional lines on the road.

4. Finally, use a mix of alizarin crimson and French ultramarine to paint shadows throughout the painting. Paint the tree trunk and branches with burnt umber and Payne's grey, and the foliage with viridian hue. Use opaque white to indicate highlights around the figures and to complete, drybrush directional lines onto your work.

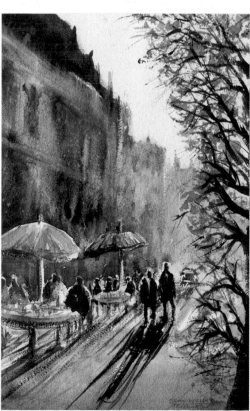

Drawing a portrait in pencil

Sue Sareen

When many people draw a portrait, they start with the overall shape rather than thinking about where the focal point of the face is. By starting from the central focal point and working out instead, the proportions of the face and features are kept realistic and characterful, resulting in a portrait to cherish.

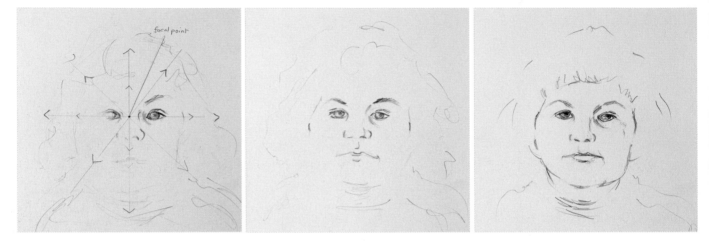

YOU WILL NEED:

Pencils/pens: B pencil

Paper/support: cartridge

Other: kneaded eraser

1. Draw a rough outline of the face to ensure it fits the paper well. Starting at the focal point or image centre across the top of the nose, work in detail from the inside of the eyes outwards to the opposite corners, and upwards towards the eyebrows.

2. Continue to apply the facial elements from the centre outwards, step by step. Draw from the eyes across to the side of the face, then from the inside corner of the eyes down the side of the nose to its tip and on to the top of the mouth.

3. Continue to draw from the inside to the outside: from the eyebrows to the hairline, from the top of the mouth to the inside then on to the corners of the mouth, the bottom lip and the chin.

4. Draw from the inside of the hairline outwards, up to the top of the head then across to the side; also down from the neck to the subject's jumper. Use the kneaded eraser as required to correct or soften marks.

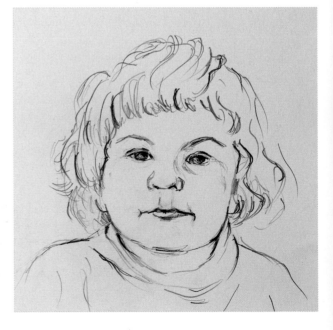

Underpainting to create depth and tone

Warren Sealey

In this portrait I use a technique called 'underpainting' to bring my subject to life. By using hard pastels for the underpainting, the colour doesn't clog the paper and blends beautifully with the soft pastel layer on top. You can apply this technique to other portraits and subjects, thus bringing all your pastel paintings real depth of colour and tone.

YOU WILL NEED:

Sennelier soft pastels:
vermillion 080, 081, 082, 083, 084, 085, 086, 088; yellow ochre 113, 115, 116, 117, 119; cadmium yellow orange 196, 197, 198; cadmium yellow deep 610, 612, 613; cadmium yellow light 297, 298, 299, 301; orange lead 037, 038, 039, 040, 041, 043, 044; burnt sienna 456, 457, 458, 460, 462; grey 514, 515, 516, 517, 518, 519, 520, 521, 523, 524; black 526, 513; white 525, 527

Pastel pencils: No. 18 natural sienna; No. 38 madder lake; No. 48 flesh

Conté carré crayons: red; green; purple; yellow

Paper/support: pastel paper, smooth side

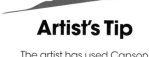

Artist's Tip

The artist has used Canson pastel paper.

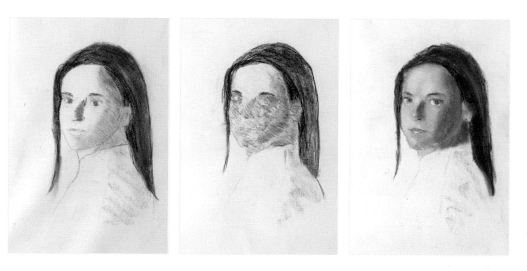

1. Draw the main shapes of the portrait using the warm brown pastel pencil, taking care to apply the proportions correctly – take your time with this first part. Shade the shadow areas using the same warm brown to establish some form and to break up the dark and light areas.

2. Create an underpainting, first applying hard green Conté in receding areas such as the side of the face and neck. Next apply purple Conté around the eyes then red Conté on the cheeks, the nose and chin, as more blood flows to them. Lastly apply yellow Conté on the bony forehead.

3. To apply the soft pastels, cover the whole light side of the face with a skin colour and rub it in with your fingers – I used yellow ochre with a touch of vermillion on top for this. Add some highlights then blend using a light toned sharp pastel pencil. Work into the shadow side with the soft pastels, adding cadmium yellow orange highlights on the side the light is coming from.

4. Continue to blend with the pastel pencils, using a light yellow to create a pleasing colour harmony throughout the face. Keep adding more light with the soft pastels, then work on the details with a pink pastel pencil to make all the elements truly accurate. To complete, apply the background.

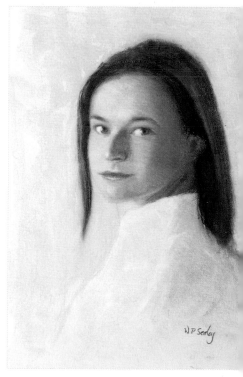

Seascapes & Water

Adding detail with a colour shaper

Ali Cockrean

Colour shapers are tools originally used to smudge and blend soft pastels. However they are also invaluable for adding impressionistic detail, such as a distant townscape, to acrylic paintings.

YOU WILL NEED:

Acrylics: red black; titanium white

Paper/support: acrylic paper, canvas or canvas board with pre-painted acrylic landscape

Other: Size 2 colour shaper with firm taper point; medium trowel palette knife

1. To add buildings to the horizon of your pre-painted acrylic landscape, first use the colour shaper and red black paint to scribble in some marks along the horizon line. Ensure your marks are in proportion to the rest of your painting.

2. While the paint is still wet, scribble over the top of this dark tone with a light mix of red black and titanium white using the colour shaper. Don't try to create specific building shapes; simply allow the paints to create their own shapes. Introduce blended areas and crisp lines of contrast to make the effect look more natural.

3. Work until you are happy with the effect. Then, using very tiny amounts of the background colours on the flat of a palette knife, push the paint into the marks you have made to soften and break the edges. This will ensure they merge successfully into the distance.

4. Once you have finished, take time to look at the painting from a normal viewing distance to ensure that the effect is working successfully. If necessary, continue to adjust the marks until you are happy with the result.

Painting swells in the sea

Barry Herniman

There can be few things more challenging and exciting than sketching and painting in front of the ever-changing sea. This project will show you how to create an evocative swell by using the immediacy and transparency of watercolours.

YOU WILL NEED:

Artists' watercolours: pure yellow; Indian yellow; orange; rose madder; madder brown; cobalt blue; helio turquoise; manganese violet

Gouache: white

Pencils/pens: 2B pencil

Brushes: No. 8 round; No. 4 rigger; old brush

Paper/support: 300gsm (140lb) watercolour block

Other: blue masking fluid

Artist's Tip

The artist has used Schmincke Horadam artists' watercolours, Da Vinci Cosmotop brushes, Hahnemühle Quatro block and Schmincke masking fluid.

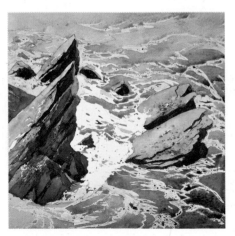

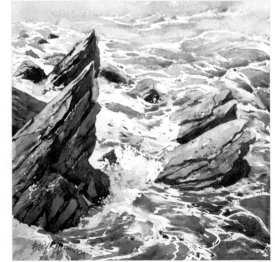

1. Using the 2B pencil, sketch in the main outlines of the subject, keeping the pencil work to a minimum. Then with an old brush and blue masking fluid, mask out all the white foam, keeping these areas loose and free.

2. Using wells of wet watercolour and the round brush, start to lay in washes of cobalt blue, helio turquoise, pure yellow and a touch of manganese violet for the sea. Then using Indian yellow, orange and manganese violet, paint in the base colours of the rocks, spattering paint here and there to create texture.

3. Now start to establish the darker shadow areas on the rocks with a stronger mix of cobalt blue, madder brown and manganese violet. Let the colours mix on the paper to preserve the individual tones and keep the colour vibrant. Remove the masking fluid to reveal the white foam underneath.

4. Use the rigger to add more details to the rocks, then drop light shadows into the sea with a dilute mix of cobalt blue and rose madder. Now strengthen the shadow areas in the rocks with cobalt blue and madder brown; finally layer in more foam trails with white gouache.

Creating a textured seascape

Celia Olsson

Incorporating textured media and collage into watercolours to create unique three-dimensional effects is great fun. You can source collage materials from newspapers and tourist information so it's relevant to the scene you are painting. Apart from the shop-bought textured media I have used here, you can also create interesting effects using household items: salt, cling film (plastic wrap), soap, wallpaper paste, acetate from food packets, and so on.

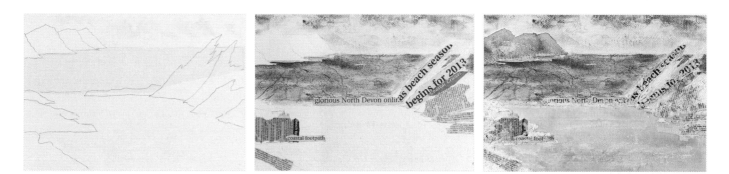

YOU WILL NEED:

Watercolours: ultramarine blue; cerulean blue; raw sienna; Indian yellow; brown madder

Acrylic ink: white

Brushes: Size 12 with a good point; rigger; old brush for gluing

Paper/support: 535gsm (250lb) minimum watercolour

Other: palette knife; crumpled tissue paper; textured media – newspaper, magazine, tourist information; natural sand; glass beads; ceramic stucco; gesso; PVA glue; kitchen towel

1. First draw the main shape of the beach and cut the crumpled tissue paper to fit the sea area, taking care to keep the horizon line straight. Flatten this out and glue to the surface. Using a palette knife, add a little gesso to parts of the sky and glue natural sand to the foreground.

2. Now wet the sky and with the Size 12 brush, apply ultramarine blue and cerulean blue above the horizon, wiping off paint from areas of gesso with kitchen towel to form clouds. Wet the sea and apply a variegated wash of ultramarine blue and a little cerulean then tear pieces of your collage papers and glue to the rock areas. Leave to dry.

3. Using a palette knife and your finger, apply a selection of textured media – newspaper, natural sand, glass beads, ceramic stucco and gesso – to the rock areas. Paint the foreground sand with Indian yellow, raw sienna and brown madder, and the distant cliffs with ultramarine blue and brown madder, mixing colours on the paper rather than in the palette.

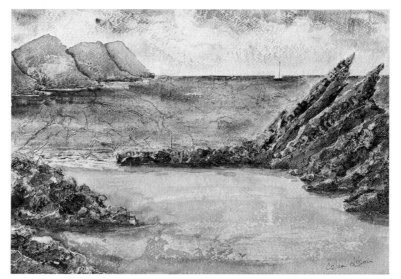

4. Add brown madder, ultramarine blue and raw sienna to the rocks, creating light and dark areas. Use white acrylic ink to define light areas on the rocks and to create small waves on the sand. Add an ultramarine blue and brown madder mix for the shadow areas, and paint a small yacht with the white acrylic ink and brown madder to complete.

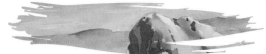

Developing a painting with washes

David Webb

My method of painting is to build up a series of washes, starting with the palest and gradually working through to the darkest. The first wash is very loose and covers virtually the entire sheet, creating the overall atmosphere and binding the composition together. With the second wash I paint the larger shapes and forms, then finally I complete the painting by adding shadows and details.

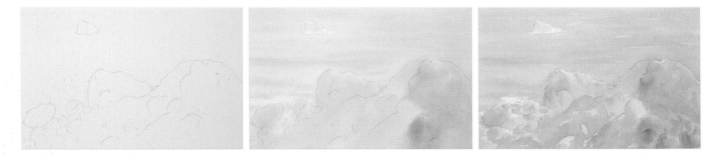

YOU WILL NEED:

Artists' watercolours: cobalt blue; alizarin crimson; burnt sienna; raw sienna; aureolin yellow

Pencils/pens: 5B pencil

Brushes: 10mm and 15mm pure squirrel mops

Paper/support: 38 x 56cm (15 x 22in) sheet of 425gsm (200lb) watercolour paper NOT stretched onto a board

1. Start by using the 5B pencil to outline the subject on the pre-stretched sheet of watercolour paper. Outline the main shapes only; if you include too much detail at this stage, you risk the painting becoming too rigid and losing freshness.

2. After diluting all the colours in separate wells, wet the surface of the paper with the large mop brush. While still damp, brush cobalt blue into the sea then work in some aureolin yellow wet-in-wet. To create the foreground and rocks, use the mop to mix burnt sienna and cobalt blue for the rocks, with a little alizarin crimson for the large rock on the right. Allow to dry.

3. Using the large mop brush, begin to create more solid forms with mixed raw sienna and cobalt blue. For the cooler greens, mix cobalt blue with aureolin. Still blending colours on the paper, leave gaps here and there to allow the first wash to show through. To create distance use warmer mixes in the foreground, such as raw sienna and cobalt blue, then use cooler, paler washes in the background.

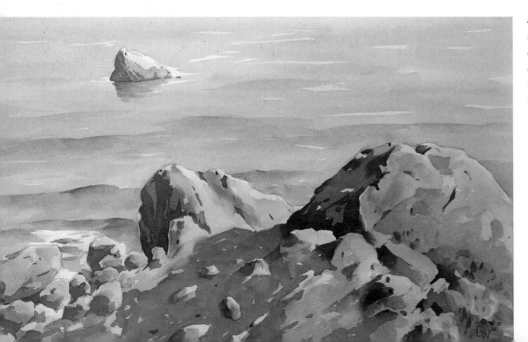

4. Finally introduce shadows using the smaller mop brush, blending cobalt blue, alizarin crimson and burnt sienna in varying quantities to achieve variety. Ensure the shadows become less distinct towards the background to help create a feeling of depth in the finished painting. To complete, add a little definition to the foreground waves.

Artist's Tip

The artist has used Saunders Waterford watercolour paper.

Using black canvas to paint a waterfall

Jayne Good

This is a quick and easy way to paint dramatic oil paintings. By painting on a black canvas the contrast between light and dark is immediate and very effective.

YOU WILL NEED:

Oils: alizarin crimson; phthalo blue; titanium white; Van Dyke brown; dark sienna; sap green; yellow ochre; cadmium yellow

Brushes: 1in landscape; No. 6 fan; liner

Paper/support: stretched canvas prepared with black gesso

Other: odourless thinners; liquid clear base paint; liquid white base paint; palette knife

Artist's Tip

The artist has used Bob Ross oils, brushes, thinners and base paint.

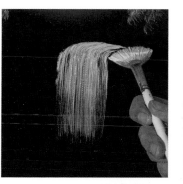

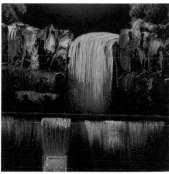

1. With the 1in brush, apply a thin coat of liquid clear to the black canvas then use a mix of alizarin crimson and phthalo blue to cover the entire surface area. Now with the 1in brush and titanium white, paint a light glow in the sky; rub in the moon with your finger and brush gently across to blend.

2. Using sap green, yellow ochre and cadmium yellow, tap tree shapes into the sky with the 1in brush, adding twigs and branches with the liner brush. Fully load the fan brush with titanium white and liquid white then brush across and down, lifting the brush gently from the surface to create the waterfall.

3. Now with the palette knife, paint rocks using your browns and titanium white. Taking the 1in brush, pull titanium white vertically down from the bottom of the falls to create reflections in the water, blending them horizontally. Tap with the corner of a clean 1in brush to create mist at the bottom of the waterfall.

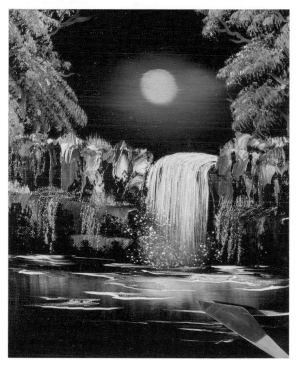

4. Finally, using the palette knife loaded with a roll of liquid white, cut in water lines at the base of the rocks and into the water then add spray with the 1in brush tapped into liquid white. Tap grasses amongst the rocks with the fan brush to complete your waterfall.

Building a sea scene with graphite blocks

Dee Cowell

Creating unusual effects and achieving dramatic results has always appealed to me – XL graphite blocks provide me with the freedom to explore. I can move from drawing into painting as the blocks are watersoluble, and using their accessories I can create exciting textures.

YOU WILL NEED:

XL graphite blocks: dark Prussian blue; olive green

Brushes: 1 in flat

Paper/support: watercolour

Other: XL sprinkler; spritzer

Artist's Tip

The artist has used Derwent XL graphite blocks, Derwent XL sprinkler and Derwent spritzer.

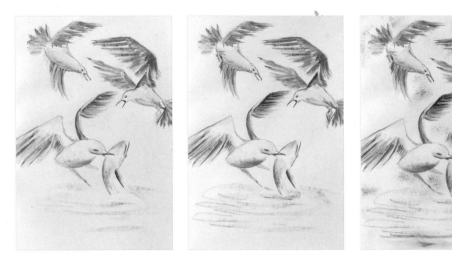

1. Using the side of the Prussian blue block, lightly sketch the seagulls and the fish. Drag the block sideways to create wider strokes for the wings and tail feathers, then use the olive green block to add detail to the feathers. Wet the flat brush and drag the paint to form the shapes of the feathers, allowing paint to run.

2. Lift paint directly from the olive green block with the damp brush and paint the lighter tones of the underbelly and legs. Then use the tip of the Prussian blue block to add details such as the eyes and beaks, also adding more detail to the feathers.

3. Next use the sprinkler to grate and sprinkle both colours around the birds in the sky then use the spritzer to spray water onto the paint granules, allowing them to dissolve naturally. Take care not to disturb the paint granules with your brush.

4. To finish, create the effect of first sea spray then water in the same way, by grating the graphite and spritzing it. Allow the graphite to dissolve then take the brush and pull paint around to create the impression of ripples in the water.

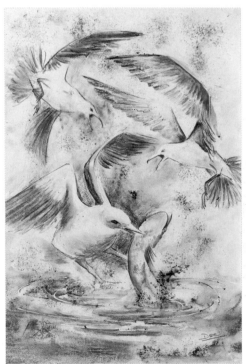

Painting a cresting wave

Denise Allen

I am constantly delighted by the play of light on water, and have devised this method of painting this challenging but exciting subject. The secret is to paint the shape of the sea before you start to add all the surface bubbles and froth. Breaking the process down like this makes it much easier, so happy painting!

YOU WILL NEED:

Oils: titanium white; ultramarine blue; cerulean blue; phthalo blue; burnt umber; yellow ochre

Brushes: 1 and 1in flats; Nos 2, 4 and 10 rounds

Paper/support: 50 x 100cm (20 x 40in) box canvas

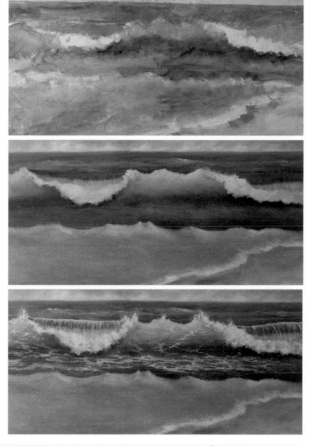

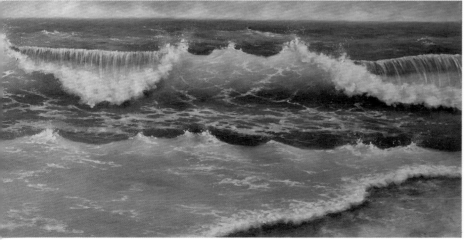

1. First roughly block in the colours to establish proportions and colour balance using the 1in flat brush. Use a mix of ultramarine blue, cerulean blue and titanium white for the sky. For the deeper water use ultramarine blue and burnt umber. Add phthalo blue to the mix for the outer area of the cresting wave, and for the underneath begin to add small quantities of yellow ochre. Mix ultramarine blue, phthalo blue, yellow ochre and titanium white for a lighter version of the water moving into the foreground. Then apply a mix of yellow ochre and burnt umber for the small area of sand.

2. Now create the shapes of the water. Add some phthalo blue and titanium white to the ultramarine blue and umber mix for the deeper water, and begin to suggest some waves. Continue using ultramarine blue and phthalo blue on the cresting waves and blend this into the titanium white as the wave rolls over. Add to this mix yellow ochre for the transparent area of the wave and the foreground, using the 1.5in flat for this layer. The result will look dark, which will allow the contrast to show at a later stage.

3. Next start adding detail, painting white caps in the distance using a mix of titanium white and a little ultramarine with the no. 4 round. Then drag white in the direction of the breaking wave using the No. 10 round to represent the air being dragged through the water, creating bubbles. Add light and shadow to the froth along the edge of the breaking wave with a mix of blues and white, again using the No. 10 round.

4. Finally, add foam in the foreground with a No. 2 round and titanium white by painting a connected lace of ellipses on the middle wave, and a more broken one in the front. Add definition to the roll of foam along the sand with a mix of blues and white for shape, and a shadow under the foam with a mix of ultramarine blue and burnt umber. To complete, spatter some spray around the wave.

Using light to create a Mediterranean scene

Jeremy Ford

In this afternoon scene of Kefalonia, light and contrast dictates the tone and colour of the Mediterranean – from the gently cresting waves to the sweep of the foreground as it drops down into the sea. The distant trees are also captured by the way the light plays on their tops and creates soft shadows underneath.

YOU WILL NEED:

Artists' pastels: cobalt blue; white; light earth or flesh; cream yellow; pale grey; dark grey; subtle khaki; yellow ochre; cream; blue grey; black; orange; various yellows; greens; greys; blues

Pencils/pens: 2B pencil

Paper/support: PastelMat

Other: lightweight board or table; masking tape; pastel blender

1. Tape the pastel paper on all four sides to a lightweight board; when the tape is finally removed it will create a nice, sharp edge to the picture, a little like a mount. Using a 2B pencil with light pressure, draw the basic outline of the picture on the PastelMat paper; this is always my paper of choice for chalk pastels because of its ability to grip multiple layers of pastel, thus negating the need for fixative.

2. Now apply cobalt blue to the sky area using the whole side of the chalk, not the tip. Overlay the lower part of the sky with white in the same way then use your fingers to work the pastel into the paper, creating a soft sky. Blend in every direction until the effect is as smooth as possible then draw in the white clouds, softening very gently with a finger in the direction they are moving.

3. Cut a strip of masking tape and place it over the top of the sea where it meets the land. Now lightly apply and blend in the hill colours of light earth or flesh, cream yellow, pale grey and subtle khaki then use the tip of the white to create the impression of distant buildings. Remove the masking tape and place it over the hills at the bottom where they meet the sea.

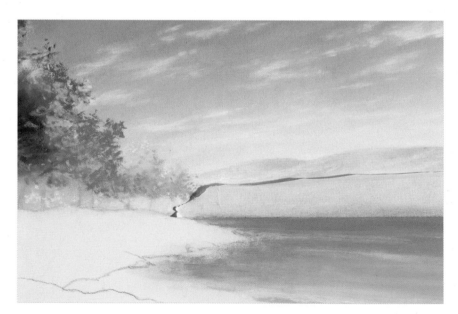

4. Next combine various greens, yellows, black, orange, blue and grey to create the trees, using the tip of the pastels around the edges, softening the underneath with a finger, then adding in more detail. Apply the sea lightly, as you did for the sky, right up to the masking tape using a deeper blue. Overlay some areas with yellow and white for the shallower colours, along with the blue used in the sky and white for the wave crests. Blend a little to create the softness of the sea.

Artist's Tip

The artist has used SAA artist's pastels.

5. Now remove the masking tape to reveal the straight edge of the sea. Add white to the crests of the waves and gently soften with a finger. Use a pastel blender with a flexible rubbery plastic tip to soften some of the detail – using a finger might be too large and clumsy in a small area. Create the tree trunks with grey and black, blending a little with the blender.

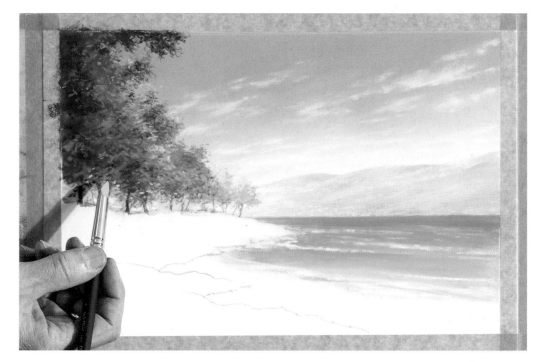

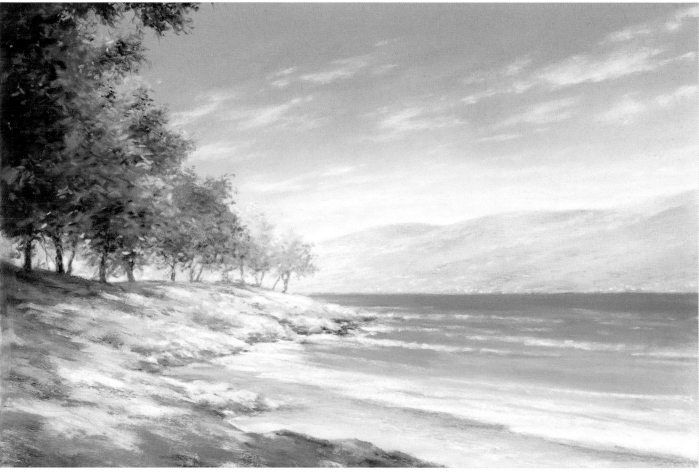

6. Use yellow ochre for the sand, overlaid with white for paler areas, and dark grey for darker areas near the sea. Blend, then work over lightly with the tip of the white to create the impression of shells, and the tip of the dark grey near the sea to look like shingle. Starting with the palest colours, apply the rocks with a combination of yellow ochre, cream, pale grey, blue grey, dark grey, orange and white, softening here and there with the pastel blender; use a little black very sparingly, carefully blending it with the other colours. Finally remove the masking tape to leave nice, clean white edges.

Painting a lighthouse using creative watercolour effects

Matthew Palmer

In this project, I'll show you how to paint one of my favourite subjects – a wonderful seascape with a lighthouse. The steps feature different techniques, many of which are essential for developing your watercolour painting. Enjoy it and don't be afraid to make mistakes; realizing where you went wrong and trying again is how an artist develops and improves.

YOU WILL NEED:

Watercolours: natural grey (you can mix your own from 60% French ultramarine, 10% alizarin crimson and 30% yellow ochre but avoid using Payne's grey); natural yellow or yellow ochre; natural blue or French ultramarine; intense violet; viridian hue; burnt sienna; opaque white or white gouache

Brushes: Sizes 6 and 20 rounds; Size 2 rigger or liner; old or masking brush for masking fluid

Paper/support: 300gsm (140lb) NOT ¼ imperial or A3-sized watercolour

Other: masking tape; board for your paper; palette; pencil; water pot; kitchen towel; a plastic card; masking fluid; natural sponge

Artist's Tip

The artist has used Matthew Palmer's watercolours and SAA artists' watercolours.

1. Sketch in your subject outline with a pencil then use an old brush or masking brush to carefully apply masking fluid to the lighthouse. Next add a strip of masking tape just below the horizon line; before adding the tape, remove some of its stickiness by rubbing your fingers over the surface a few times.

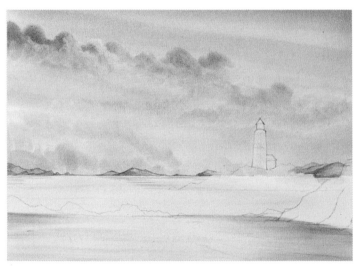

2. Prepare pale washes of intense violet and natural blue then a stronger natural grey; wet the sky area down to the tape. Using your Size 20 round, first add violet to the bottom half of this area, followed by blue then grey. Dab the excess paint off your brush then gently roll in the clouds, using kitchen towel to lift out some lighter ones. Leave to dry. Next paint a few distant grey cliffs then remove the tape and use a pale viridian mixed with natural blue to paint the sea; use natural yellow to paint the beach at the same time.

3. With a strong mix of natural grey and a touch of burnt sienna, paint the rocks one area at a time. While the paint is still damp, use the plastic card to firmly wipe or scrape off the paint – this creates a wonderful rock effect, even more so if you experiment by using different parts of the card. Use the Size 6 round to paint horizontal reflections at the bottom of the rocks and a dark area between the sand and water's edge, blending away to the left.

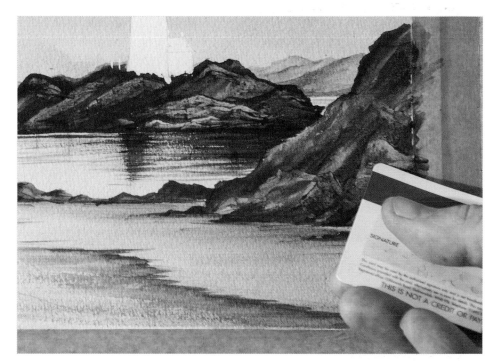

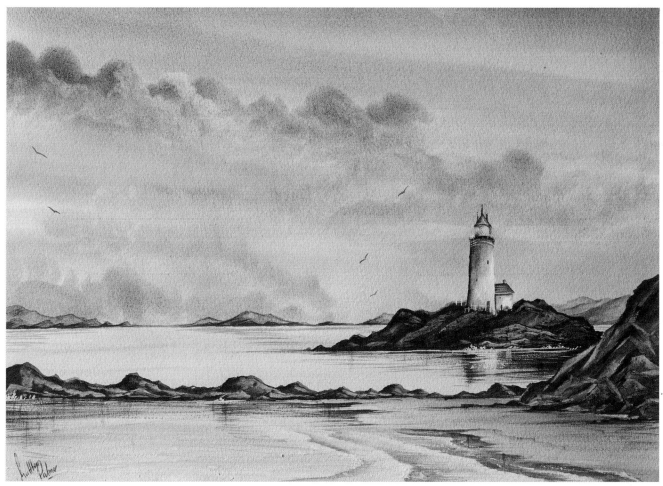

4. Now remove the masking fluid on the lighthouse. Use opaque white to add splashes and waves, again blending away to the left. Add darker grey shadows to the right of these and to the lighthouse, using a damp Size 6 round to blend. Use natural grey with the rigger to apply detail to the house and lighthouse, adding the light in the lighthouse with natural yellow and using burnt sienna to paint the roof on the house. Finally, add a few seagulls and finishing touches then wipe out the lighthouse beams with the card and a damp natural sponge.

Capturing the freedom and freshness of plein-air painting

Steve Higton

Living in East Anglia gives me access to many lovely beaches, which are the inspiration for this work. My technique has evolved mainly through trial and error, but is most useful for introducing a plein-air feeling to my studio work. Painting boldly and with speed, using the minimum of brushstrokes provides the work with the desired freedom and freshness.

 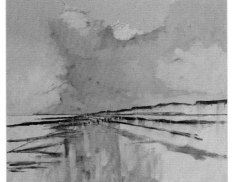 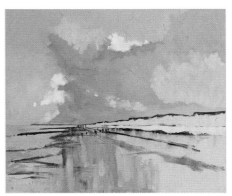

YOU WILL NEED:

Oils: French ultramarine; permanent alizarin crimson; white; Naples yellow; burnt sienna; olive green

Acrylics: cadmium red

Brushes: Nos 00, 2, 4, 6, 8, 10 and 12 flats

Paper/support: 50 x 60cm (20 x 24in) pre-stretched canvas

Other: gesso; whiting powder or white chalk dust; charcoal; turpentine

Artist's Tip

The artist has used Winsor & Newton Monarch short flat brushes.

1. First prime your canvas by applying two coats of gesso mixed with cadmium red acrylic and whiting powder – this will create a warm pink colour with a rough texture. Draw the basic form using charcoal then add the dark tones with the No. 4 flat and a mix of French ultramarine, permanent alizarin crimson and white, liberally thinned with turpentine.

2. Next add the sky colour with the No. 12 flat using French ultramarine and white, varying the colour depth towards the horizon line. With burnt sienna added to the same mix, lay in the darker sections of the clouds, again varying the mixes to create dark and light areas. Lay this same colour onto the beach area in vertical strokes.

3. Now introduce lighter elements to the clouds using the No. 8 flat with white and Naples yellow, also using this colour to paint the sand areas. Create a slightly lighter white and Naples yellow mix then use this with the No. 6 flat to make the dunes a little greyer and to paint the base colour of the sea.

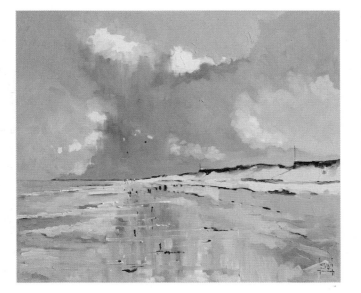

4. Paint the main body of the sand using the No. 10 flat and a mix of white, Naples yellow and burnt sienna, blending into the reflected area with vertical strokes. Add final details to the sea and sand with the No. 00 flat. To complete, use olive green and Naples yellow to paint highlights on the dunes and seaweed on the shore.

Painting sparkling light on sea

Paul Acraman

I love painting the constantly changing colour, light and movement of the sea. Capturing the sparkling light on the water is something many artists struggle with, but by using a palette knife and a slightly looser style, that illusive shimmer can be caught on paper.

YOU WILL NEED:

Artists' acrylics: titanium white; cerulean blue; burnt umber; phthalo blue or Winsor blue

Brushes: two large flat nylon

Paper/support: 300gsm (140lb) watercolour

Other: painting knife; palette

Artist's Tip

The artist suggests using Galleria or System 3 artists' acrylics.

1. Add titanium white and a mix of cerulean blue, a little burnt umber and a spot of white to your palette. Wet the paper then generously apply titanium white over the entire surface; using the same brush, apply the blue mix with light, direct strokes, leaving a paler area for the light.

2. Using the second clean, dry brush, gently blend the blue paint smooth before it dries. Next spread a little titanium white across the palette in a thin layer then load one edge of the painting knife with this colour by sliding it a little way across the thin paint.

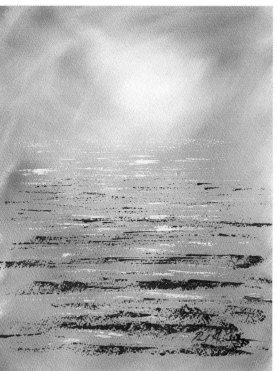

3. Gently touch the knife edge loaded with titanium white on and off the paper with a tapping motion to form sparkles in the water. Move the knife from side to side and up and down between the taps, keeping the marks horizontal. Reload the knife edge as necessary.

4. Mix phthalo or Winsor blue with a little burnt umber and a spot of white. Loading the knife as before, tap some darker marks into the lower half of the sea area, then make larger marks in the foreground using a sliding, sideways movement.

Using a twig to paint line and wash

Sean Coupe

This fun technique, using a twig or bamboo cane dipped in ink, will loosen up your painting and make you more expressive. So relax, enjoy the process and let your drawing develop organically; the idea is to be free with your movements, not restrained.

YOU WILL NEED:

Artists' watercolours: yellow ochre; lemon yellow; cobalt blue; burnt umber

Indian ink: black

Brushes: Nos 10 and 14 round watercolours

Paper/support: 300gsm (140lb) hot-pressed watercolour, minimum A4 size

Other: twig or cane measuring no less than 30cm (12in) in length; shallow dish for ink

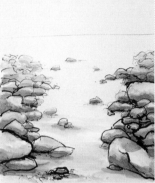

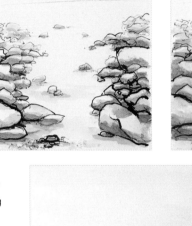

1. Hold your twig at arm's length – working from your shoulder or elbow – for increased expression; avoid using pencil length twigs, as these will only tighten your drawing. Start to outline your subject by drawing directly with the ink; apply strong lines in the foreground with weaker ones in the background to create a sense of depth. Leave to dry.

2. Next apply layers of thinned Indian ink with the No. 10 brush. Apply the lighter tones first, building up your ink washes to create a tonal painting with a full range of lights through to darks. Allow the washes to dry then add more ink where stronger tone is needed. Leave to dry.

3. Now apply a wash of yellow ochre to the rocks and foreshore with the No. 14 brush. Then mix equal parts of cobalt blue and lemon yellow to create a seaweed-green colour, applying this to the tops of the rocks. Intensify the colour with further washes then apply burnt umber to the rocks for added depth.

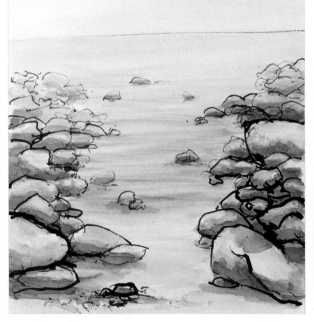

4. Finally mix the sea colour by adding a brush tip of yellow ochre to cobalt blue. Using the No. 10. brush, apply washes of this with horizontal, linear strokes to the sea area, starting intensely in the foreground and softening the colour towards the horizon. To complete, darken the colour with more blue and apply with a random linear stroke.

Painting a breaking wave in acrylics

Melanie Cambridge

Beaches make fabulous subjects for paintings where light, colour and contrast play such a major role. I hope that my simple guide to painting a breaking wave will encourage you to have a go.

YOU WILL NEED:

Artists' acrylics: ultramarine blue; cerulean blue; titanium white; yellow ochre; burnt sienna

Pencils/pens: pencil

Brushes: No. 10 acrylic flat

Paper/support: acrylic

1. Draw out the composition in pencil. With burnt sienna and ultramarine blue, paint the rocks using thick paint and textural marks. Mix yellow ochre, a little burnt sienna and titanium white thinned with a little water, then paint the beach using bold, horizontal strokes.

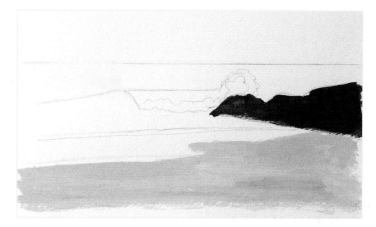

2. Paint the wave backwash and beneath the breaking wave with cerulean blue and yellow ochre, using upward, sweeping brushstrokes to provide movement. Now apply titanium white for the water in front of the wave then mix ultramarine blue and yellow ochre to paint the deep sea in the distance.

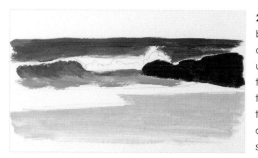

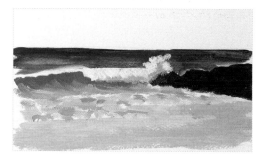

3. Paint the breaking wave with thick white paint, adding a little pale blue for shadows within the crashing foam. Apply speckled marks of both pale yellow – mixed from yellow ochre and titanium white – and pale sea green – mixed from cerulean blue, yellow ochre and titanium white – to create the effect of foam rising up the beach.

4. Now add a line of thick titanium white paint above the speckled foam marks. Mix a touch of cerulean blue with plenty of titanium white then streak this onto the rocks where the water is flowing from them. Add a few extra streaks on the beach to finish your painting.

Capturing sea and spray in oils

Roy Lang

It is a passion for the natural and infinitely variable beauty of the sea that drove me to capture its moods and power. I chose oil paints for their ability to blend; and their smooth texture and body naturally enhances the depths and movement of the oceans. Oils on troubled water!

YOU WILL NEED:

Oils: titanium white; French ultramarine; burnt sienna; cadmium yellow; yellow ochre; scarlet lake; cobalt blue; sap green

Acrylics: yellow

Brushes: No. 6 filbert; No. 4 round acrylic; large mop; script liner; 25mm low cost household painting brush

Paper/support: 40.6 x 30.8cm (16 x 12in) canvas board

Other: black gesso; thinners in a pot; palette; knife; kitchen towel

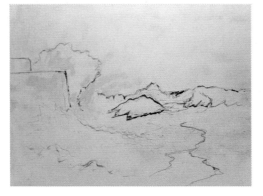

1. Thin a small amount of yellow ochre with water and wash this over the board using the large mop brush. When this wash is dry, sketch the scene with thinned gesso.

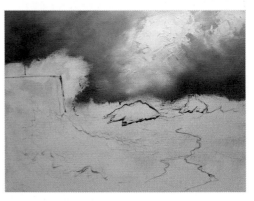

2. Paint the sky using the filbert with a mixture of French ultramarine, burnt sienna and titanium white. Now using the palette knife, create a break in the cloud by applying a paler blue then titanium white, tinted with cadmium yellow and a speck of scarlet lake.

Artist's Tip

The artist has used Daler-Rowney Georgian oils and an SAA large mop.

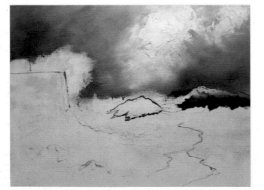

3. Next paint the top third of the wave with a mix of cadmium yellow and titanium white, the middle third with sap green, and the lower third with a mix of French ultramarine and burnt sienna, blending each application with the acrylic brush. Then use the script liner to paint in the outline of some debris.

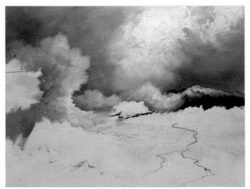

4. Paint the areas of foam burst using a touch of cobalt blue into white, with a touch of burnt sienna, but leave out areas that will catch the sunlight. Now paint these sunlit areas with cadmium yellow into white, taking care not to overwork them as varying tones and colours will create three-dimensional form.

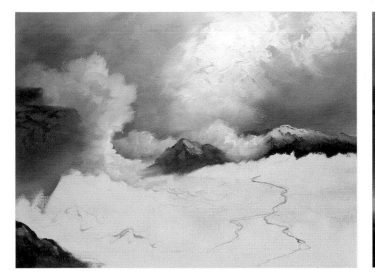

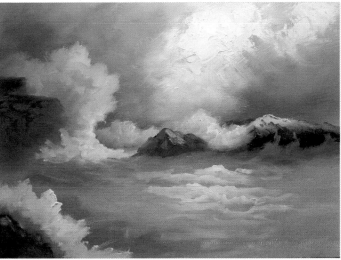

5. Paint the rocks and harbour wall areas using a mix of four parts French ultramarine to one part burnt sienna. As you paint towards the foam, allow the brush to run out of paint and fade, thus creating the impression that the rocks and walls are being engulfed by spray. Where the sun would naturally hit the rocks, apply yellow ochre into white highlights, using the round acrylic brush with a sideways sweeping motion.

6. Using the filbert, block in the foreground sea with varying tones of cobalt blue into white. Then with the script liner, paint the detailed foam patterns on the front of the wave. Again using the script liner and a mix of white with hints of red and cadmium yellow, highlight the foam below the cloud break.

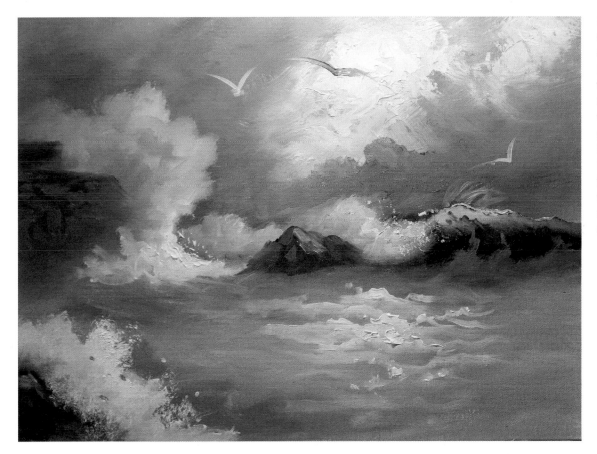

7. Darken the sky just above the foam to provide contrast. Use the script liner with titanium white to paint some wisps of spray on the top of the wave then paint in a few gulls. Use the household brush dipped in the foam highlight mix to stipple the foam areas, adding a few individual spots of the mix with the script liner to create splashes.

Still Life

Drawing a convex surface in relief

Clive Riggs

In order to make curved surfaces appear three-dimensional, it is necessary to place light and shadow in the appropriate areas to create the illusion of form. The following steps outline a process developed in the Renaissance that will help you to achieve this illusion on all convex surfaces.

YOU WILL NEED:

Pencils/pens: unsharp HB, B and 2B pencils, with a flat area on the leads

Paper/support: cartridge

Other: warm, sticky kneaded eraser

1. Using an egg as your model, draw the outline gently with the HB pencil. Next apply a light background tone, using the blunt end of the pencil and long strokes. Then indicate the cast shadow underneath the egg; do not worry about neatness at this stage.

2. Lay a flat, even tone to the egg by crosshatching with the blunt B pencil. Continue with this until the tone is even and light; do not apply much pressure, just gradually build the tone. Once this is done, tap out the highlight on the top right of the egg with the kneaded eraser.

3. Indicate a reflected light on the underside of the egg by hatching in the shadow area toward the bottom edge of the egg with the B pencil. Build and darken the tone with short hatching strokes that follow the contour, leaving the very bottom edge of the egg light.

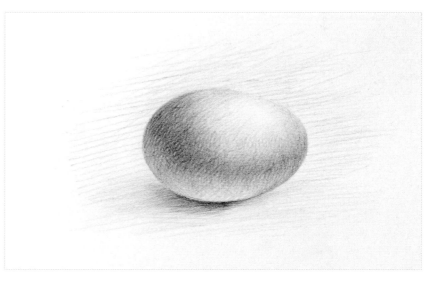

4. Finally, darken any shadow areas as necessary by crosshatching, and darken the background tone by hatching. The background as a midtone should contrast light against dark against light. Use this system on all objects with surfaces that are raised in the middle to achieve a luminous and three-dimensional result.

Layering colours with watercolour pencils in a still life drawing

Gary Greene

This project employs the burnishing technique, which involves gradually layering sequences of colours, blending each completed sequence and then repeating the sequences until the entire subject surface is covered.

YOU WILL NEED:

Watercolour pencils: burnt ochre; canary yellow; cool grey 50%; cool grey 30%; crimson lake; light umber; limepeel; orange; pale vermilion; poppy red; scarlet lake; Spanish orange; sunburst yellow; Tuscan red; vermilion; yellow ochre

Coloured pencils: crimson red; Spanish orange; warm grey 20%

Paper/support: regular (rough) surface vellum, 2- or 3-ply, or equivalent

Other: kneaded or battery-operated electric eraser

1. Using well-sharpened coloured pencils, lightly draw outlines of your subject. These should be in colours that correspond to the area of colour to be painted: for the yellow areas use Spanish orange; for the red areas use crimson red; and for the shadow use warm grey 20%. Do not use excessive pressure to avoid creating grooves in the paper.

2. Starting with the mango's yellow half, layer the darkest yellow values, using light pressure and a constantly sharpened point. Overlap each layer with lighter colours of yellow ochre, limepeel, Spanish orange, sunburst yellow and canary yellow, ensuring coverage is consistent.

Artist's Tip

The artist has used Prismacolor Premier watercolour pencils, Prismacolor Verithin coloured pencils and Strathmore 500 Bristol vellum.

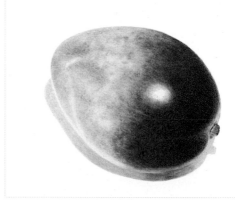

3. Next, paint the red side of the mango. Layer dark to light with first Tuscan red then crimson lake, scarlet lake, poppy red, pale vermilion, orange and Spanish orange. Leave areas of white paper to represent the highlights.

4. Finish by shading the stem in cool grey 30%, burnt ochre, light umber, yellow ochre and vermilion then the shadow in cool grey 50%, 30%, yellow ochre and Spanish orange.

Using oil pastels for a simple still life

Judith Champion

People are often wary of using oil pastels because the colours can be considered harsh and unnatural. The secret is to overlay the colours and blend to achieve subtle shades; oils pastels have the added advantage of not requiring fixing like soft pastels. Try this project to produce a mini oil painting!

YOU WILL NEED:

Oil pastels: yellow ochre; Rowney yellow; crimson lake; French ultramarine; white

Watercolours: alizarin crimson

Brushes: watercolour

Paper/support: small piece of mount board

Artist's Tip

The artist has used Daler-Rowney oil pastels.

1. Simple subjects are often the best, in this case an apple on a plate. First break off approximately 2cm (¾in) pieces of the pastels you are going to use and unwrap them. Loosely sketch out the shape of the apple and plate in a pale colour, using yellow ochre to produce a pleasing composition.

2. Start to fill in a yellow undercoat for the apple using Rowney yellow, leaving a few white areas for highlights, and use some yellow ochre to define the top of the fruit. Using the French ultramarine pastel on its side, lightly sweep some colour over the plate and background.

3. Now start to gradually add more colours, blending by layering one colour onto another. Apply the crimson lake and yellow ochre pastels over the apple in curved strokes, then rub some white over the plate area to blend.

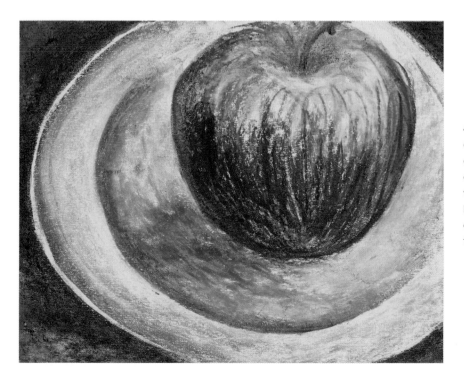

4. Add some shadows to provide depth using dark blue. Add the stalk with a mix of colours already used: a dash of French ultramarine over yellow ochre. For a final touch, add a juicy wash of alizarin crimson watercolour to the background area – the pastel acts as a resist for an interesting texture – and around the edges of the board for a finished look.

Painting hats with tonal counterchange

Kaye Parmenter

Tonal counterchange is a great concept to have in mind when you are planning your painting and it is something that I use in practically every piece I paint. With careful use of tone on adjacent shapes, you can bring a subject to life and create form. Even with a restricted palette and simple shapes, you can paint something quite striking.

YOU WILL NEED:

Watercolours: phthalo blue; ultramarine blue; burnt sienna; alizarin crimson; raw sienna; cadmium orange

Brushes: Size 8 round; Size 2 detailer

Paper/support: watercolour

1. Counterchange is the term that describes the reversal of tonal relationships between a form and its background. In this case the left-hand side of the hat is dark against a light background, and the right-hand side of the hat is light against a dark background. For this project, try painting each hat individually first.

2. For each hat, follow the same process. For the blue hat, at the top use phthalo blue, and at the bottom use ultramarine blue and burnt sienna. To paint the red hat, use alizarin crimson and cadmium orange. To paint the orange hat, use raw sienna and cadmium orange. Paint the feathers in the same colours.

3. For each hat, paint a line of clean water from top to bottom in the middle and just above the hat where the feathers are. Mix a wash and paint from left to right into the water. For the feathers, use the detailer brush and paint into the water above.

4. Using the same technique, paint all three hats together in a row. Wait to dry and add some finer detail to the bow and feathers. Add a wash of raw sienna under the blue hat brim, above the blue hat top and around the right hat brim to define the edges.

Using acrylic glazes to paint a still life

Julie Nash

Glazing is the technique of using thin, transparent layers of colour to subtly enrich or modify your painting. Here I'll show you how easy it is to use glazes to create the effect of translucent light through a still life subject, in this case, grapes.

YOU WILL NEED:

Acrylics: cadmium yellow; cadmium red; alizarin crimson; ultramarine blue; titanium white

Brushes: small round acrylic; small filbert

Paper/support: hot-pressed watercolour

Other: stay-wet palette

Artist's Tip

The artist has used SAA acrylic brushes.

1. First use the filbert brush to apply a thin base layer of cadmium yellow and cadmium red, placing the cadmium yellow where light will be shining through the grapes and cadmium red where they will be in shadow. Blend them together to create a soft transition and a suggestion of roundness. Let this dry.

2. Prepare a mix of purple using alizarin crimson and ultramarine blue, then paint alizarin crimson over the main body of each grape, blending in the purple mix where the grapes will be in shadow. The first layer will show through this, but now the colours will be deeper and richer. Again, let this dry.

3. Repeat the previous step, strengthening the grape colour with another glaze and adding more purple to the darkest shadow areas to increase the tonal range and roundness. Deepen the colours with more glazes if you require even darker grapes. With a greenish brown mixed with cadmium yellow, ultramarine blue and cadmium red, paint the stalk.

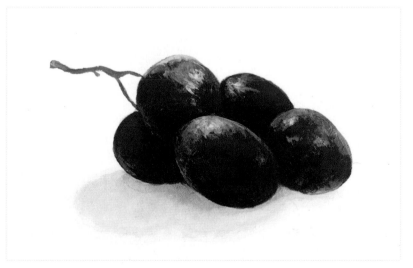

4. Finally mix pale blue and pale purple by adding a speck of each to titanium white. Then use a damp brush to moisten the grapes, suggesting the surface bloom on the fruit by using the round brush to stipple on tiny amounts of these pale mixes. Also use these colours for the shadow, diluting them at the outer shadow edges.

Lifting out colour for realistic highlights

Katherine Macleod

This is a great technique for anyone wanting to achieve realistic effects with the minimum of effort. I love lifting out colour, as there will often be a glow in the highlight left on the paper that you can't replicate. You can use this method to create all manner of detail, from fish scales to mortar, or whiskers to clouds.

YOU WILL NEED:

Watercolours: permanent rose; cadmium yellow pale; cobalt blue; indigo; opera rose; cadmium scarlet; yellow ochre; cadmium red deep; cadmium orange

Pencils/pens: 2H pencil

Brushes: Size 14 round; 1in goat hair mop; Size 10 round sable; Size 1 flat acrylic; Size 2 round sable

Paper/support: 425gsm (200lb) watercolour

Other: kitchen towel

1. With the 2H pencil, make a swift drawing of the beanie to familiarize yourself with the rows of stitching. Then using the Size 14 round brush, wet the paper and apply light washes of yellows, pinks and touches of cobalt blue to the beanie. Leave to dry.

2. Paying closer attention to the colours, now prepare four mixes: permanent rose and cadmium scarlet, yellow ochre and cadmium orange, cobalt blue and permanent rose, then indigo and permanent rose. With a large brush, apply these four mixes as loose but heavier washes on dry paper.

Artist's Tip

The artist has used Winsor & Newton watercolours and Hahnemühle watercolour paper.

3. Now dampen the flat brush with clean water by tapping it once onto kitchen towel to remove any excess water – this will prevent any cauliflower patterns from developing. Then lift out half a stitch at a time, keeping the shapes simple and following their direction.

4. Now that the stitches are visible, you can spend some time deepening areas of colour behind their rows to push each one forward. Once dry, re-apply colour to the stitches, leaving more of them white to produce a 'fuzzy' effect.

Bringing life to your painting with white

Linda Pitcher

You will gain more experience and a sense of achievement by painting from real life; working directly in front of your subject also allows you to see colours and shadows more accurately. The structured process outlined below – making a good drawing, adding dark tones, then local colour – prepares your painting for the final stage of introducing white to your mix and life to your painting. Remember to paint the whole painting in stages rather than one object at a time; by doing this your painting will look complete rather than disjointed.

YOU WILL NEED:

Acrylics: French ultramarine; cerulean blue; burnt sienna; cadmium red; cadmium yellow; yellow ochre; titanium white

Brushes: No. 12 filbert; No. 16 round

Paper/support: board painted with acrylic primer and wiped with a thinned mix of French ultramarine and burnt sienna

1. The first stage is to draw the subject with your brush. On a dry, toned board, paint the outlines and shadows using a thinned mix of burnt sienna and French ultramarine with the No.12 filbert. Do not add any detail yet and don't worry about making any corrections to your work.

2. Now observe the still life with half-closed eyes to establish the darkest areas without worrying about their colour. Using thinned French ultramarine and burnt sienna, paint these shapes with the No. 16 round, keeping the application loose and without adding any detail.

3. Next observe the local colour of the objects – for example, the vase is predominately blue. Paint these mid-toned colours with thinned paint to allow the drawing and shadow areas to show through them. The colours will appear strong now, but will soften when the final layers are applied.

4. Finally, add titanium white to your palette of colours, making sure that the mixture is stiff in consistency. By doing this, the colours become less intense (chalky) and thicker in consistency (opaque). Paint the detail with a drybrush loaded with paint, enjoying the process as the paint breaks the surface to leave areas underneath untouched.

Depicting straw with sgraffito

Lynne Castell

As it can be difficult to achieve intense colour when applying light oil pastel over dark, try this sgraffito technique where you will scrape through the top layers of pastel to reveal the colours beneath.

YOU WILL NEED:

Oil pastels: dark naples ochre 184; cadmium yellow 107; light cadmium yellow 105; light flesh 132; Van Dyck brown 176; black 199; (warm) white 101; cool grey 2 231; cool grey 4 233; olive green yellowish 173; medium flesh 131; pink madder lake (pale peach) 129; light violet 139; purple violet 136; earth green 172

Paper/support: pastel paper, smoother side

Other: kneaded eraser; manicure set tools or penknife or palette knife

Artist's Tip

The artist has used Faber Castell oil pastels and Canson Mi-Teintes pastel paper.

1. Apply the straw colours first in dark naples ochre, cadmium yellow, light cadmium yellow and light flesh, then paint the areas where strands are likely to extend in front of darker colours in Van Dyck brown and black. Apply the background wood panelling and old plaster wall in a variety of colours.

2. Next apply shadow colours over the straw colours in Van Dyck brown, black, cool grey 4 and earth green, including over the edges where strands may extend, for example, against the wooden and old plaster walls and the stone floor slabs. Smooth the pastel with the back of your fingernail or a curved tool, such as the cuticle pusher from a manicure set.

3. Continuing to work with the cuticle pusher, a penknife or a palette knife, now scratch out straw strands, feathering them out against the walls and lying loosely on the floor. Vary the direction and shape of the strands so that they are not all parallel or in neat rows – remember, they'll naturally appear quite tangled.

4. To complete the straw effect, scrape out slightly larger and wider strands in the foreground to increase perspective. You do not need to spray your piece with fixative, but brush off any loose particles before mounting and framing.

Layering acrylics and oils to create bold colour

Sue Deighton

I am painting *Marmande Tomatoes* with water-mixable oil paint. My top tip is to complete the first stage of the painting in acrylic so that the colours will not bleed into subsequent layers of oil paint, resulting in a stronger, bolder colour and a quicker drying time.

YOU WILL NEED:

Water-mixable oils: cadmium red hue; viridian; cobalt blue; cadmium yellow pale hue; titanium white

Acrylics: cadmium yellow; yellow ochre; burnt sienna; ultramarine blue; crimson

Pencils/pens: 2B pencil; artists' pen

Brushes: Size 2 round acrylic; Size 6 filbert

Paper/support: acrylic oil

Other: palette; water pot

Artist's Tip

The artist has used Winsor & Newton Artisan water-mixable oils, Atelier Interactive artists' brushes, a Faber Castell Pitt pen and Hahnemühle acrylic oil paper.

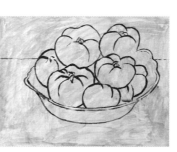

1. Draw the subject with the 2B pencil then work over this outline with pen, rubbing out the pencil. Now with acrylics, understain the paper using a mix of yellow ochre, cadmium yellow and ultramarine blue with the Size 6 brush. Use the Size 2 brush to draw the tomatoes with crimson and the bowl with a mix of ultramarine blue and crimson.

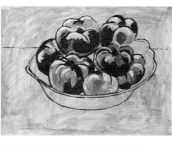

2. Now switch to oils and with the Size 6 brush, paint the fruit using cadmium yellow pale hue, cadmium red hue, viridian and titanium white, in that order. Allow the brushstrokes to reflect the tomato shapes and paint inside the existing lines, thus allowing the brush drawing to show.

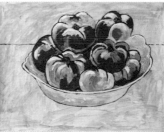

3. Still with the Size 6 brush, paint the bowl with mixes of titanium white, cobalt blue and cadmium red hue, using bold strokes that follow its shape. Next add a lip to the bowl with titanium white then mix viridian with cadmium red hue and use this dark mix to paint the bowl's contour shadows.

4. Paint in the shadow first, using blue-violet mixes made from cobalt blue, cadmium red hue and titanium white. For the remaining background, mix cadmium yellow pale hue and titanium white then have fun using directional brushstrokes to create a lively texture, which provides a foil for the rhythmic brushstrokes on the tomatoes.

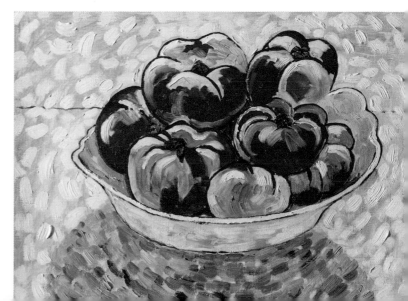

Using a magic watercolour sponge eraser

Sharon Hurst

Painting fantasy subjects often calls for an unusual technique. I was struggling to find an effective method for creating smoking cauldrons, fizzing magic wands and mist. When I started to experiment with a magic watercolour sponge eraser, it all just came together in an instant!

YOU WILL NEED:

Artists' watercolours: Payne's grey; quinacridone gold; scarlet lake; burnt umber; raw sienna; indigo; burnt sienna

Brushes: Nos 3, 6 and 8 rounds; large hake; old or masking brush for masking fluid

Paper/support: 300gsm (140lb) watercolour paper

Other: magic watercolour sponge eraser; blue masking fluid; bar of soap; palette; pencil; salt (optional)

Artist's Tip

The artist has used Bockingford watercolour paper.

1. Outline the candle on your paper with a pencil. Prepare the masking brush by wetting it then rubbing it into the bar of soap to protect the hairs. Now mask out the candle, the rock base, and a thin line of light above the flame.

2. Position your watercolour paper at a 45-degree angle and wet it until it is dripping. Pour Payne's grey and indigo into the same well then loosely mix with the large hake. Now use these colours to lay the background, applying horizontal stripes across the paper and allowing the colours to run. Then remove this background from around the flame with the magic sponge eraser.

3. Next use Payne's grey and the No. 8 brush to shape and shade the candle. Paint the rock using bold and wet brushstrokes, adding some cracks in the surface with the No. 6 brush; you might also like to add salt while the paint is still wet for texture. Then smudge quinacridone gold around the outer edges of the masked candle flame and leave to dry.

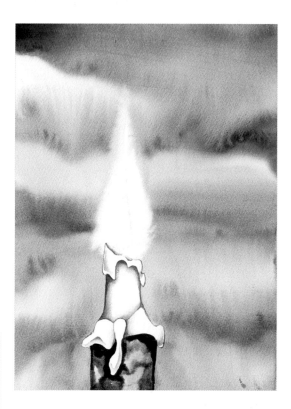

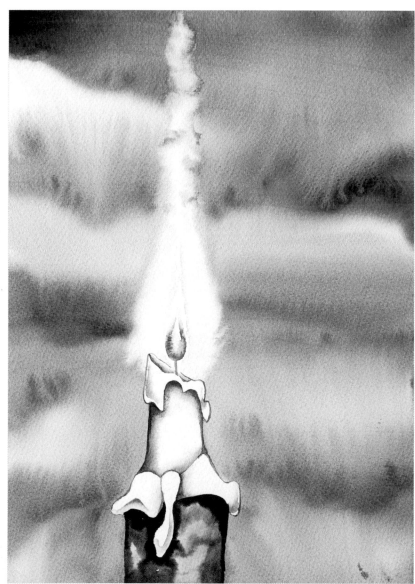

4. Remove the masking fluid then drop scarlet lake into the middle of the flame in a U shape with the No. 3 brush, adding quinacridone gold to the middle of this. Finally, use a damp sponge to create smoke above the candle then add a little Payne's grey to this area, blending in the colour with the magic sponge.

Experimenting with inks wet-in-wet

Yvonne Marie Darby

Creating an artwork with inks is exciting due to their nature as a medium. When used wet-in-wet, ink moves quickly across the paper to produce vibrant colours; when used drier, it can produce sharper lines. This mix leads to lively and sometimes surprising results, so have fun exploring!

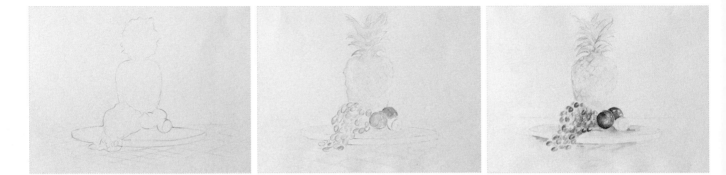

YOU WILL NEED:

Acrylic inks: process yellow; raw sienna; flesh tint; burnt umber; process magenta; purple lake; marine blue; indigo

Pencils/pens: 2B pencil

Brushes: No. 12 or No. 14 round; No. 6 or No. 8

Paper/support: medium weight NOT watercolour

Other: kneaded eraser; palette

1. First set up your composition, using a pineapple to create central height and for its leafy structure then adding more fruits to introduce different colour and forms. With the 2B pencil, make an outline sketch of the whole composition; simplifying in this way allows you to check the proportions and composition.

2. Stand back to view your sketch from a distance and make any necessary alterations. Now lightly sketch in more details, blocking off some small highlight areas. Dilute the various inks with water and apply light washes of colour, creating light and dark greens with mixes of blues and yellows.

3. Now pay attention to the direction of light, using less diluted ink washes to pick out light and dark areas on the fruits. Allow the ink to create dynamic 'bleeding' effects, which will form part of the character of the painting. Use a mixture of wet-in-wet and wet-on-dry effects.

Artist's Tip

The artist has used FW acrylic inks.

4. In the final stage it is time to become bold with the inks. In small areas use these undiluted and wet-in-wet to produce special effects. Look carefully for really dark areas and use several layers to build tonal contrast and perspective. A vibrant, colourful and lively artwork is your finished picture!

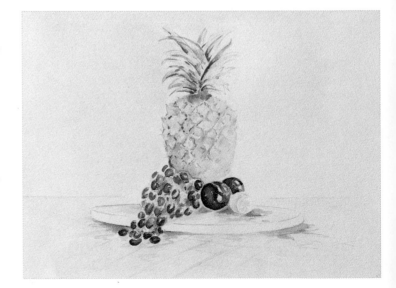

Painting a lamp with acrylics and moulding paste

Terry Chipp

Impasto techniques can be used to great effect to create real texture and interest. In this exercise, you will be creating the effect of lamplight falling across an old plastered wall, emphasizing the impasto nature of the wall through the way the light bounces off the rough surface.

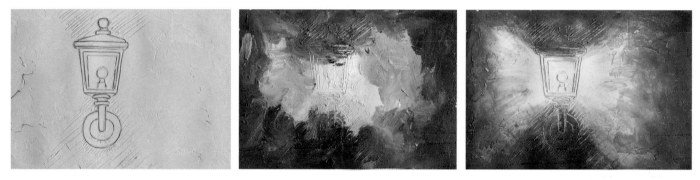

YOU WILL NEED:

Acrylics: titanium white; arylamide yellow; yellow ochre; burnt sienna; phthalo blue (red shade)

Pencils/pens: B pencil

Brushes: Size 6 round acrylic

Paper/support: 51 x 41cm (20 x 16in) 18mm stretched canvas

Other: moulding paste; kitchen towel; Italian painting knife or palette knife

1. Prepare the canvas by applying a layer of moulding paste with a large palette knife to create a rough, broken texture. Use a pencil to quickly draw the lamp design into the wet paste then scratch into the shadow areas to create extra texture.

2. Thoroughly wet the entire surface. Now use kitchen towel to apply paint generously across the canvas, adding these thick layers of colour to match the light – titanium white, arylamide yellow, yellow ochre, burnt sienna then phthalo blue. Don't blend the layers too much at this stage to keep them bright.

3. Starting with the lightest areas, lift off most of the paint with dry kitchen towel, rubbing until the texture and your drawing begins to show through. Soften the edges between the colours, keeping them clean. Then use a damp kitchen towel to lift off the colour around and away from the light.

4. Once you have created a suitable glow around the light, take your brush and paint the lamp in your usual way. Most of it will be in shadow, but look out for places where the light catches an edge of the casing, or is reflected from the wall.

Artist's Tip

The artist has used Atelier Interactive acrylics, an SAA brush, Paperwave canvas and Atelier Interactive moulding paste.

Landscapes
& Buildings

Sketching with two colours

Alan Goodall

Besides taking photographs, regular outdoor sketching is an excellent way to gather information for your future paintings. You can record details, especially in shadowed areas that the camera often overlooks. Outdoor sketching is enjoyable and will certainly improve your finished work.

YOU WILL NEED:

Artists' watercolours:
ultramarine blue; burnt sienna

Gouache: white

Pencils/pens: permanent pen in black (medium); 2B pencil

Brushes: Nos 2, 4 and 8 rounds

Paper/support: NOT surface watercolour, approximately A4 size

1. When sketching, use two colours to simplify your mixing process and save time. In addition, this enables you to travel lightly and collate information quickly. The early watercolourists used this method of sketching with warm burnt sienna and cool ultramarine blue; a beautiful range of greys can be made by mixing these two complementary colours.

2. Sketch the scene in soft 2B pencil and outline the main features loosely in permanent black pen. Block in the sky and main shadow areas in a medium tone of ultramarine with the large brush, retaining the architectural features as white paper. Also block in the main door and window openings, and establish the tonal underpainting.

3. Paint the warm, sunlit areas in various mixes of the two colours, but predominantly burnt sienna. Darken the shadow areas, allowing the colours to mix on the paper. Establish the dark arch beneath the bridge, and paint the doors and windows in a variety of dark mixes. Retain the white architectural features.

4. Paint shadows beneath the roofs and balconies in ultramarine blue. Invent a shadow across the background buildings on the right-hand side to reduce detail and create interest. Loosely paint the railings on the left, the mooring posts and the gondola without adding too much detail. Finally paint the water, simply suggesting vertical reflections, and sharpen a few highlights with white gouache.

Using a limited palette for a winter landscape

Alan Kingwell

I chose this subject mainly to show how an instant effect can be achieved with a limited palette; how a few highlights on a painting are much more effective than too many; and how blending out a distant background can provide the picture with much more depth.

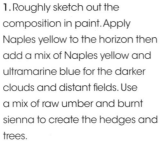

YOU WILL NEED:

Oils: ultramarine blue; Naples yellow; raw umber; burnt sienna; titanium white

Brushes: Size 10 (12mm) flat; Size 0 (5mm) flat; Size 2 rigger; Size 02 (30mm) fan blender

Other: liquin

1. Roughly sketch out the composition in paint. Apply Naples yellow to the horizon then add a mix of Naples yellow and ultramarine blue for the darker clouds and distant fields. Use a mix of raw umber and burnt sienna to create the hedges and trees.

2. Mix ultramarine blue and Naples yellow to paint the snow colour in the foreground. Roughly paint in the main tree and add some small trees in the distant wood on the left. After adding some snow to the hedges, leave to dry.

3. Using the rigger, paint the trees with a mix of burnt sienna and raw umber thinned with liquin. Darken the hedge with the same colour as the trees, introducing some detail. Repaint the snow with the dark blue mix and add the same mix to the hedge.

4. Add highlights to the snow and hedge using Naples yellow. Paint the snow-covered ferns and broken branches with the rigger then use a mix of ultramarine blue and raw umber to paint the icy puddle in the centre of the lane.

Artist's Tip

The artist has used Atelier Interactive Acrylic flat brushes, Daler-Rowney Aquafine rigger and fan brushes, and Winsor & Newton Liquin.

Painting a mountain scene using textures

Ali Hargreaves

I have always loved bright colours and textures, so I incorporate them in my mixed media work. I am constantly experimenting, and particularly like the effects you can get when using textured wallpaper for both collage and printing.

YOU WILL NEED:

Acrylics: yellow ochre; titanium white; Prussian blue; violet; process magenta

Pencils/pens: water-resistant pen

Brush: flat

Paper/support: rough watercolour stretched onto board

Other: gesso; textured wallpaper; corrugated cardboard; mounting card off-cuts; white tissue paper; PVA glue mixture of 2 parts glue to 1 part water

1. Sketch the scene using the water-resistant pen. Next use glue to stick the collage materials – textured wallpaper, corrugated cardboard, off-cuts of mounting card and tissue paper – to the surface, following the lines of the mountain edges. Scrunch the tissue up before you apply it over the glue, stippling with the brush to encourage the creases; use mainly for the cloud areas.

2. Now paint the entire piece with gesso. Once dry, apply some loose acrylic washes in various colours by diluting the paint with water and using your flat brush to create a background cover.

3. Add more colour by using your acrylics more thickly this time. Once dry, cover the flat brush with a layer of thick colour and glide it over the textured area, keeping the brush flat to highlight the raised areas. Use a circular motion when painting the white clouds over the tissue.

4. Add print texture by loading the brush and painting a strip of textured wallpaper, keeping the brush flat and using a sideways motion. Place the painted strip of wallpaper face down on top of the work to add print texture and apply pressure. Accentuate the steepness of the mountain with corrugated cardboard prints.

Creating an atmospheric wet-in-wet landscape

Arnold Lowrey

It is important to make sure you decide on subject, mood and focus when painting a landscape. The wet-in-wet technique can help you achieve an evocative and atmospheric landscape with real focus and interest, and lends itself beautifully to water and reflection studies, just like this landscape.

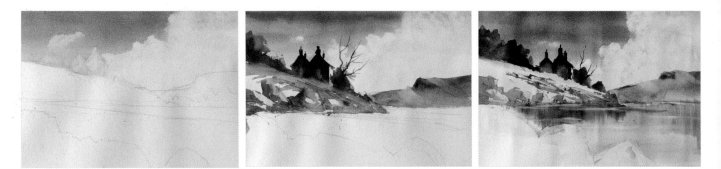

YOU WILL NEED:

Artists' watercolours: cobalt blue; ultramarine blue; cadmium red light; lemon yellow; cadmium yellow; burnt umber

Pencils/pens: soft pencil

Brushes: large wash brush; small detailer

Paper/support: watercolour

Other: kitchen towel; razor blade

1. First, draw out the composition. Then wet the sky area and paint in some cobalt blue with the large wash brush half loaded with water. Mix ultramarine blue with a touch of cadmium red light then paint into the existing blue. While the wash is wet, use kitchen towel to gently lift out the clouds, taking care not to rub the paper surface.

2. Now paint in the far headland with a darker mix of the same sky colour. Then with the smaller brush, paint in the house and trees using ultramarine and a little cadmium red light; paint the field using first a wash of lemon yellow then cadmium yellow. Add in some rocks below using burnt umber and ultramarine blue.

3. Using the large wash brush, wet the water area and paint it with cobalt blue. While this is still wet, add reflections by mixing some of the colour applied to the rocks with a little water and pulling the colour down into the water, letting the water soften the effect. Clean the brush and water then pull out some light ripples.

4. Now mix some rock colour and paint the foreground rock shapes, ensuring they are different structures and sizes. While moist, scrape out the light sides of these rocks with a razor blade, making sure that these are the sides facing the light.

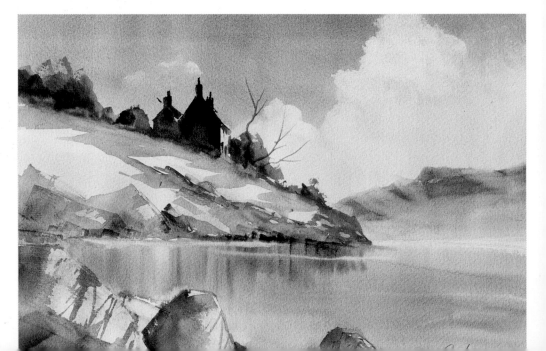

Painting 'one way'

Charles Bezzina

'One way' means painting a stage and then moving on to the next. If we are always going back and adjusting early parts of a painting, there is a danger that we will lose the immediacy of those initial markings. By painting in this manner, the impact and freshness are preserved.

YOU WILL NEED:

Acrylics: Mars black; French ultramarine; phthalo green; alizarin crimson

Oils: phthalo blue; French ultramarine; alizarin crimson; cadmium yellow; titanium white; cerulean blue

Brushes: Size 4/6 flat or 4/6 filbert; soft brush to blend colours

Paper/support: 300gsm (140lb) minimum watercolour or mount card

Other: MDF board; gesso; linseed oil; turpentine; sand grain paper; kitchen towel

1. Staple a piece of mount card or watercolour paper to MDF board. Brush three coats of gesso across this, lightly sanding the paper between coats. Then brush some acrylic colours across – I suggest bright colours such as French ultramarine, phthalo green and alizarin crimson. Leave to dry completely.

2. In acrylic, paint the mountains to act as the underpainting. When completely dry, apply a prepared mixture of linseed oil (80%) and turpentine (20%). Brush the surface sparingly to ensure it does not become saturated; if it does, remove some of the mixture with kitchen towel.

3. Sparingly introduce colour into the sky area using phthalo blue, French ultramarine and alizarin crimson oils, with a touch of titanium white and cadmium yellow. Gently blend the colours on the wet surface using a soft brush for as long as you wish, but you must do this gently.

4. If the mountains are saturated with the mixture, wipe some off using kitchen towel. Gently, from left to right, paint the mountains in alternating mixes of tonal blues and bring in some white to represent the snow and glaciers. Finally blend some colours in the foreground using the soft brush.

Adding warmth to a snow scene

Betty Norton

A snow scene can often appear cold, but by adding some subtle washes of colour at the start you will not only add warmth, but also more interest. After all snow is not stark white, as it reflects colour from its surroundings.

YOU WILL NEED:

Watercolours: lemon yellow 608; yellow ochre 604; cadmium red 506; quinacridone magenta 403; French ultramarine blue 102; light red 504

Brushes: Silver Wash Size 16; Silver Flatmate

Paper/support: good quality watercolour

1. Using clean water and the large wash brush, wet the sky area and work from the horizon upwards, first touching in some lemon yellow followed by cadmium red. Layer more cadmium red above, and then add French ultramarine blue and magenta. Apply the same colours, only paler, in reverse order below the horizon then allow to dry.

2. Next mix a pool of shadow colour with French ultramarine blue and light red. Use this mix and the large wash brush to paint the trees behind the farmhouse and across the horizon, dotting the colour randomly and varying the shapes and heights as you work. Allow this to dry.

3. Using yellow ochre and the large wash brush, paint the walls and chimneys of the buildings. Then paint the fir trees, using the flatmate brush and your shadow colour. Wash the brush, wring it out and use it to lift some colour off for the tree trunks; do this in short lengths, leaving some areas for foliage.

Artist's Tip

The artist has used SAA watercolours and SAA brushes.

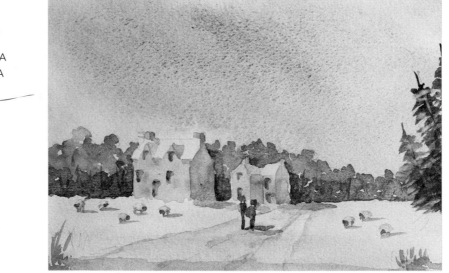

4. Again using the large wash brush and a weak mix of your shadow colour, paint the shadow sides of the buildings. Drag the colour across the ground to set them down then use the same colour to add the windows and doors. Finally paint the road tracks, figures and sheep, flicking some shadow colour across the ground.

Using colour to capture a Mediterranean scene

Charles Evans

When painting the Mediterranean, your choice of colour is paramount in bringing the heat and vibrancy of the view to life. From the pre-wash to the final detail, colour can add an extra depth and dimension to a painting, transporting the viewer in such a way that they can almost tangibly feel the ambience of the landscape.

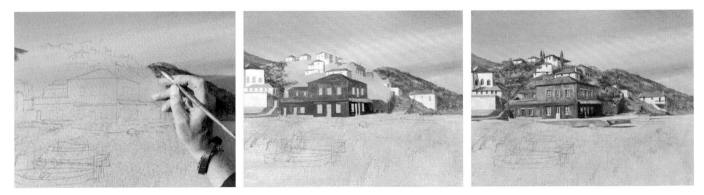

YOU WILL NEED:

Artists' acrylics: Naples yellow; cobalt blue; titanium white; burnt sienna; raw sienna; Payne's grey; raw umber; Hooker's green; alizarin crimson

Pencils/pens: 2B pencil

Brushes: 28mm and 18mm flats; No. 8 round; Size 3 rigger

Paper/support: 300gsm (140lb) acrylic

1. Start by applying a raw sienna pre-wash across the canvas then make the outline drawing. Fill in the sky area using a large flat brush with a mixture of cobalt blue and titanium white. For the distant hills, apply a mix of raw umber and burnt sienna, and for the warm tones use a mix of cobalt blue and alizarin crimson.

2. Next paint the buildings in titanium white, using cobalt blue to denote the shadow areas and a mix of burnt sienna and raw umber for the roofs. Use a mix of alizarin crimson, titanium white and burnt

sienna to paint the bottom of the main building, followed by raw umber and Naples yellow for the top. For the trees, mix Hooker's green, burnt sienna and touches of Naples yellow then apply with the round brush.

3. To paint the windows, use Payne's grey and a touch of cobalt blue with the rigger brush. Then use a mix of cobalt blue, alizarin crimson and burnt sienna for the shadows, picking out the strong, diagonal shadows cast by one part of the building onto another.

Artist's Tip

The artist has used Winsor & Newton artists' acrylics and Winsor & Newton Galeria and Cotman brushes.

4. Fill in the boats using various colours, ensuring that you give them different shapes. For the water, use the No. 18 brush to apply a strong mix of cobalt blue and Hooker's green, along with touches of titanium white here and there to pick out the light areas. To complete, create some reflections in the water by applying areas of darker mixes.

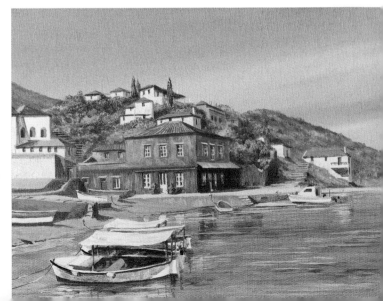

Creating clouds with soft tissues

Claudia Nice

This resist technique using facial tissues is the result of one of those 'what if' moments I had while experimenting with wet watercolour washes. The resist works really well to protect white paper areas, while producing spontaneous, anything-can-happen edges – soft, blended perimeters, runs and blooms, hard edges or lacy frills. I love the technique for creating fluffy cumulous clouds, and it would also work well to block out areas for distant tree foliage, coral reefs, flower gardens and abstract designs.

YOU WILL NEED:

Artists' watercolours: cobalt blue; cadmium orange; basic palette for a foreground scene

Brushes: ½in flat; No. 4 round detail

Paper/support: 23 x 30cm (9 x 12in) sheet of 300gsm (140lb) cold-pressed watercolour

Other: backing board; masking tape; plain, non-enhanced soft tissues

1. To prepare, tape all the edges of your watercolour paper to a backing board. Wad three or more tissues in your hand and briefly submerge them in water, then position the wet wads on the surface of the dry paper to represent clouds, allowing some to overlap naturally. Working from the top down, apply a wash of cobalt blue horizontally across the dry sky area, using the flat brush in sweeping, overlapping strokes, and adding water to lighten the paint as you approach the horizon. Paint up to and touching the wet tissue clouds, which will darken along the edges.

2. While the paint still has a wet sheen, gently remove the tissue. Use a damp flat brush or dry tissue to mop up any standing water puddles and stop unwanted paint or water runs. Also use the brush to guide spontaneous wet-in-wet flows, although remember that surprise effects are part of the fun.

3. Now mix cobalt blue, orange and water to produce a light grey wash. On a damp surface, use the flat brush to stroke shadows into the cloud areas, bearing in mind the direction from which the light is coming. Create soft edges by blending and lifting the damp paint with a clean brush, cleaning and blotting the brush between every few strokes.

4. Allow the sky to dry thoroughly then add a simple foreground landscape of a coastal sand dune with dry beach grasses and stubby pines. Use a dark green to bring a dark value contrast to the composition and a round detail brush to suggest the grass blades.

Eliminating detail from a reference source

Bob Hughes

A common problem for many artists when using a reference image is the amount of detail that they can see in it, which is both irrelevant and distracting. Beginners in particular try to incorporate everything they see into their painting, sometimes resulting in a laboured effect. This technique will show you how you can eliminate most of the detail, resulting in a spontaneous style

YOU WILL NEED:

Acrylics: yellow ochre; phthalo green; raw sienna dark; napthol crimson; phthalo blue; cobalt blue hue; arylamide yellow deep; arylamide yellow light; titanium white; Indian yellow; quinacridone magenta

Brushes: No. 6 filbert; large detailer; rigger

Paper/support: 640gsm (300lb) rough ¼ watercolour

Other: A4 tracing paper; Tracedown or tracing paper; masking tape; retarder; liquefying medium (premix)

1. Place a sheet of tracing paper over the image to defuse it slightly; it may be necessary to use two sheets, as some tracing papers are more opaque than others. Pay attention to the values, not the small details.

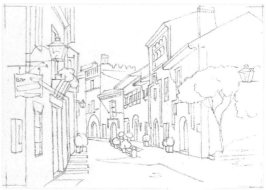

2. Trace the image, leaving out all the ornate detail including the various brickworks and mouldings. Transfer the tracing onto the rough watercolour paper, which can be done with Tracedown, using the masking tape to secure this in place.

Artist's Tip

The artist has used Atelier Interactive acrylics, Winsor & Newton Artisan brushes, Imperial Arches watercolour paper, Atelier Interactive retarder and liquefying medium.

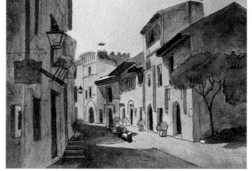

3. For the underpainting, mix the phthalo blue and cobalt blue for the sky then mix small amounts of oranges, yellows and browns for the rest. Use the No. 6 filbert with premix to thin the paint, scumble in all the colours; the drawing should show through.

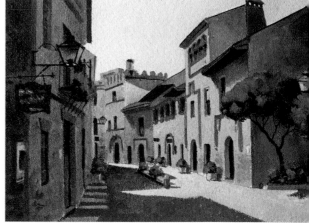

4. Paint the buildings on the left with darker tones. Mix and apply warm colours to the right. For the shadows on building sides, mix a small amount of phthalo blue, napthol crimson, and a hint of titanium white with warmer colours. Add purple for shadows on the street.

Capturing the essence of a scene with a limited palette

Geoff Kersey

Walking along the road in a little Derbyshire village on a bright October morning, I was inspired by the light in this simple scene, so was glad to have my camera with me to photograph it. Later in the studio I set about turning the scene into a painting, deciding to opt for a limited palette of colours to capture the essence of the view.

YOU WILL NEED:

Artists' watercolours: cobalt blue; French ultramarine; viridian; aureolin; rose madder; burnt sienna; manganese violet

Pencils/pens: 2B pencil

Brushes: Size 2, 4, 6, 8 and 10 round; Size 16 wash

Paper/support: watercolour

Other: masking fluid; natural sponge

1. First draw the subject, then apply masking fluid to the highlight areas: these are along the top of the walls on both sides of the road, the road itself where it bends from view, and the two distant vehicles. Also mask the top of the hedge on the left by wetting the area with clean water then brushing masking fluid onto the wet background to create a soft, feathered shape.

Artist's Tip

The artist has used SAA brushes.

2. Using the large wash brush, apply a light grey wash for the sky mixed from cobalt blue, rose madder and burnt sienna. Next mix a cool green from viridian and manganese violet, a dark green from viridian, ultramarine blue and burnt sienna, and a rich autumn gold from aureolin and burnt sienna. Wet the background with a natural sponge and clean water before applying these green mixes wet-in-wet with a medium brush to create soft foliage.

3. Paint the hedgerow with the same autumn gold and dark green mixes, also brushing in a few touches of purple mixed from cobalt blue and manganese violet. With slightly stronger variations of the gold and cool green mixes, drybrush autumn foliage, adding a touch of brown (burnt sienna and cobalt blue) to the large tree on the left and the central tree. Once the foliage has dried, add the trunk and branch details with a smaller brush, using a dark brown mixed from burnt sienna and French ultramarine. Remove the masking fluid then brush very light washes of autumn gold and purple over the lower half of the scene.

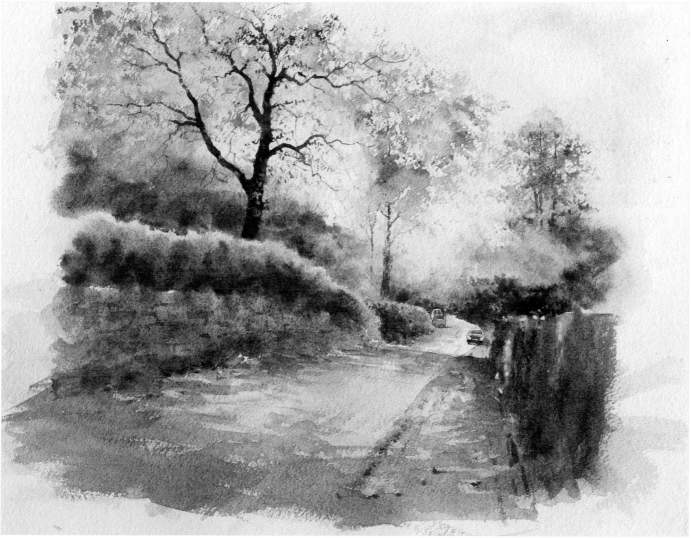

4. Finally, use the same colours in varying strengths to add detail to the middle distance and foreground, taking care to suggest this in the two walls so you retain the looseness of the painting. Using a wash of warm purple mixed from cobalt blue and rose madder, add shadows that are just strong enough to have impact and thin enough to appear translucent.

Mastering the wet-in-wet technique with oils

Gill Adlington

Painting was something I always wanted to do but failed every time I tried, until I found *The Joy of Painting* on Sky television. This wet-in-wet technique inspired me so much, and after trying it just once I knew it was something I could do. Having now trained to teach the method, I demonstrate it to others, who like me thought they couldn't paint but now find that they can – oil is a wonderful medium to use.

YOU WILL NEED:

Oils: titanium white; Prussian blue; sap green; cadmium yellow; Van Dyke brown; dark sienna

Brushes: 1in landscape; 1in oval; filbert; No. 3 fan; scriptliner

Paper/support: triple primed canvas of choice no smaller than 30.5 x 40.5cm (12 x 16in)

Other: palette; kitchen towel; sponge; odourless thinner; liquid clear or linseed oil; black acrylic gesso; detail knife

1. Create a dark area by applying black acrylic gesso with a scrunched up kitchen towel and sponge. When dry, use the 1in landscape brush and liquid clear to thinly cover the entire canvas. Now cover the black area with a thin coat of Prussian blue then use the clean 1in oval brush to thinly apply titanium white to the sky area.

2. Use the 1in landscape brush to paint the sky in Prussian blue, then add cloud shapes with titanium white. For the reflected water, apply titanium white by pulling the brush straight down towards you, and then lightly pull across. Use sap green to paint the distant hillside shapes then emphasize the foliage shapes by tapping the 1in oval brush and a green-blue mix onto the canvas.

3. Now load the oval brush with cadmium yellow to highlight the bush and tree shapes. With sap green, add the land and highlight with cadmium yellow then shape the banking on either side and highlight. Use the detail knife and titanium white to add ripples to the water with zigzag strokes. Highlight the tree trunks with titanium white and tap in the remaining foliage shapes with the oval brush.

4. Finally shape the path with a fan brush and Van Dyke brown, using a rocking stroke to add highlights with yellow ochre. Using yellow ochre, cadmium yellow and sap green, complete the grass and add bushy areas with the oval brush.

Painting textured mountains with pastels

Graham Cox

After struggling for many years with watercolour, I discovered pastel. I found that by blending a layer of colour into the paper's textured surface I could create lovely soft atmospheric backgrounds. The simple technique of lightly dragging the flat edge of a small piece of pastel across the grain of the paper, as shown here, enables features such as foliage on trees, the shimmer on distant water, and scree on mountain sides to be easily rendered.

YOU WILL NEED:

Soft pastels: blue green 4; additional 6; blue violet 5; blue violet 11; additional 36; yellow green earth 11; yellow 17

Conté pastel: black

Paper/support: 160gsm (98lb) dark blue pastel (smooth side)

Other: No. 6 soft chisel edge colour shaper

Artist's Tip

The artist has used Unison soft pastels, Hahnemühle pastel paper and a Royal Sovereign colour shaper.

1. First use the sides of the pastels and directional strokes to outline the mountain in blue violet, followed with an application of additional 36 for the shadow areas and yellow green earth for the sunlit areas.

2. Holding the colour shaper like a paintbrush, use short, directional strokes to blend the colours into the mountain. Make your strokes follow downwards from the ridge on the left, through the additional 36 colour and then curve upwards through the yellow green earth 11 to the right-hand ridge without lifting your shaper from the paper.

3. With a small piece of Conté pastel used on its side, add a little black to emphasize the darker areas of shadow so the mountain ridges stand out. Use the colour shaper to blend these marks a little, but still leave plenty of texture.

4. Finally, add a little more black Conté pastel into the shadow areas and a flash of yellow 17 along the edges of the ridges where they catch the sunlight.

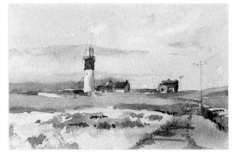

Using tonal contrast for a sunlit landscape

Grahame Booth

The illusion of sunlight can be created with strong tonal contrasts and rich shadows. Remember that light will look lighter when darks are darker, so the darker the shadows, the stronger the sunshine.

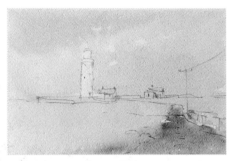
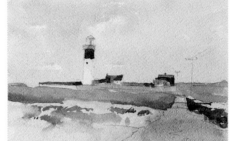
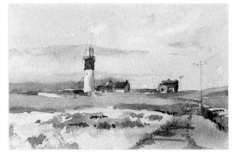

YOU WILL NEED:

Artists' watercolours:
tropical phthalo blue; French ultramarine; burnt sienna; raw sienna; aureolin; cadmium yellow; cadmium red; alizarin crimson

Brushes: Size 12 mop; Size 10 all-rounder; Kolinsky Size 6 rigger

Paper/support: rough watercolour

1. Starting at the top and working down, freely apply a wash over all the paper with the large mop leaving few, if any, hard edges. Use an appropriate colour for the various parts: phthalo blue for the sky, an aureolin and French ultramarine mix for the grass, then phthalo blue and alizarin crimson for the path. This wash will be the light in the final picture and it is important to keep this in mind as the painting develops.

2. Paint similar but stronger colour mixes with the all-rounder brush to distinguish the main shapes, including the lighthouse, walls and buildings. Then apply additional varied washes of burnt sienna and cadmium yellow to add interest to the grass. At this stage the subject is painted as if there is no direct sunlight.

3. Now use a shadow mix of phthalo blue and alizarin crimson to suggest sunlight coming in from the left. Rinse then almost dry the brush and touch it to the edge of the shadow on the lighthouse to soften it and create the illusion of roundness. Apply a darker wash to the grass in a variety of greys to add further interest and paint some extra clouds to bring tonal contrast to the sky area.

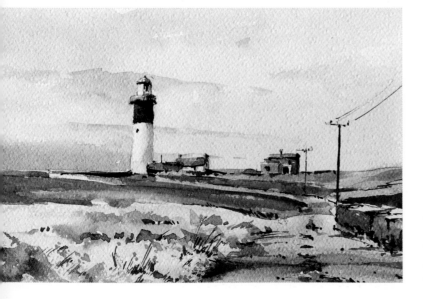

4. Finally, lay a very dark mix of ultramarine blue and burnt sienna with the rigger to provide the painting with dramatic tonal contrast. The feeling of sunshine is created by the dark mix applied next to light areas. Add a few doodles in the foreground to suggest grass and wild flowers.

Painting a moody sky with water-mixable oils

Murray Ince

Skies are one of the most, if not the most, important elements of a landscape painting. The sky sets the mood for the whole painting, whether it be a bright blue Mediterranean sky or a moody, atmospheric sky like the one here. Many of the techniques used in this dramatic sky are equally relevant to painting a more subtle, tranquil sky.

YOU WILL NEED:

Water-mixable oils: Prussian blue; cobalt blue; permanent alizarin crimson; raw umber; Payne's grey; zinc (mixing) white; yellow ochre

Pencils/pens: 2B pencil

Brushes: Nos 12 and 8 oil filberts; No. 4 round oil

Paper/support: 30 x 25cm (12 x 10in) canvas board

Artist's Tip

The artist has used Winsor & Newton Artisan water-mixable oils and SAA brushes.

1. Start by drawing the very basic shapes of the dark and lighter sky areas with your pencil, including a little landscape. Next paint the canvas board with a weak acrylic wash of cobalt blue using the round brush; doing this seals the pencil lines and removes the white canvas to help the colour and tonal value selection.

2. Mix a dark blue-grey using Prussian blue, Payne's grey and raw umber then create shades of this colour by adding quantities of zinc white. Now work these onto the canvas with the No. 12 filbert, blocking in the sky with areas of light and dark – don't use pure white anywhere.

3. Having blocked in the sky with basic colours, wipe the excess paint from the No. 12 filbert and start to blend the areas of colour together. Add a little alizarin crimson to some of the paler mixes and gently drybrush these over the base colours to create soft edges and clouds.

4. Using paler mixes and the No. 8 filbert, paint in lighter areas of the sky and the clouds in the lower section, adding a little cobalt blue just above the land. Finally paint the landscape itself using various mixes of cobalt blue, yellow ochre and white applied with the round brush.

Drawing a tonal pencil study for a painting

John Somerscales

I always think it's a good idea to produce a pencil study before launching into a full painting in any medium. This will help and encourage you to think about your painting and work out in advance the composition and the format, the tonal range (arrangements of lights and darks), and the feel and textures. Having thought about and resolved these issues within your study, you will then be free to concentrate on other themes in your painting, such as colour, atmosphere and brushstrokes.

YOU WILL NEED:

Pencils/pens: 2B, 4B and 6B pencils

Paper/support: A4 drawing pad

Other: kneaded eraser, pencil rubber

1. Having decided on a landscape format for this picture, start by drawing a grid on your paper and placing the main elements of the composition using the 2B or 4B pencil.

2. Now remove the grid lines with the kneaded eraser and work out the tonal range from the lightest to darkest areas, the lightest being white and darkest being black. With the softer pencils, start establishing this range on your drawing, describing some of the foliage and other textures through your pencil marks.

4. Moving on to building the picture in watercolour, you are now free to concentrate on your painting technique, as you have already resolved the problems of format, composition, tone and even some texture.

3. With softer pencils, continue to increase the contrast in tones. Finish off by adding details such as the windows and railings, and complete your study by rubbing out some reflections in the ford with the pencil rubber.

Creating depth and detail with pen and wash

Lavinia Hamer

Mixing ink and watercolour with pen and wash can create the effects of depth, distance and detail, while still providing a soft and subtle texture as the inks combine with the pigment. This technique can be applied not only to landscape, but to all types of observational paintings.

YOU WILL NEED:

Watercolours: burnt sienna; burnt umber; Prussian blue; ultramarine blue; yellow ochre; cadmium yellow; cadmium red light; groon

Calligraphy ink: white

Pencils/pens: fine and medium nibbed artists' pen in black; dip pen

Brushes: Sizes 6 and 10 rounds

Paper/support: 425gsm (200lb) cartridge

Artist's Tip

The artist has used White Nights watercolours, SAA watercolour brushes, a Speedball dip pen, Pitt artists' pens and Daler-Rowney cartridge paper.

1. Draw your subject with the fine nibbed pen and waterproof ink, developing fine or broken lines as you work into the distance to create the sense of perspective. Vary your marks as you work to suggest different textures in the building and foliage, but avoid actually shading.

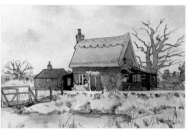

2. Now start to add loose washes of Prussian blue softened with a little cobalt blue for the sky and various washes of green and burnt sienna, Prussian blue, yellow ochre, and diluted yellow ochre for the landscape. Start with the lightest colours, working wet-in-wet to create soft areas such as the clouds and shadows, and applying flat washes or brushmarks for other areas. Allow some colours to run together to vary the applications.

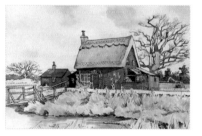

3. Start to add the details. Introduce colour accents or strengthen areas by building up thin layers of paint. Add depth by shading with transparent tone; a mix of ultramarine blue and burnt sienna makes a good wash to layer over underlying colour to create uniform shadows. Leave to dry.

4. Finally, check for areas that need sharpening with ink. Use the fine and medium nibbed pens with a light touch, as drawing over watercolour will spread the ink to create a heavier line. To complete, use the white waterproof calligraphy ink with a dip pen to add fine white lines to the piece, such as for the window frames.

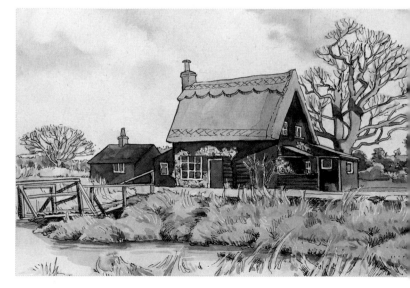

Painting snow-capped mountains

Keith Fenwick

There's something about mountain scenery that never fails to inspire any artist, independent of learning ability. Snow-capped mountain scenery adds that extra interest and excitement to the landscape that stimulates any artist, and the techniques I have developed over many years to simplify painting them are described below.

YOU WILL NEED:

Acrylics: Payne's grey: cobalt blue; alizarin crimson; raw sienna; burnt sienna; yellow light hansa; yellow orange azo; Hooker's green; vivid lime green; titanium white

Water-soluble crayon: white

Pencils/pens: soft pencil

Brushes: 1in large stippler: 1in flat; Sizes 6 and 14 rounds; Size 3 rigger; Ullswater tree brush

Paper/support: 51 x 40.5cm (20 x 16in) canvas

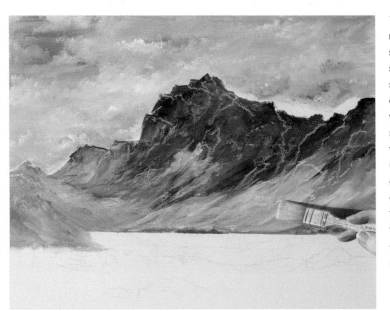

1. Carefully draw the mountain profile with a soft pencil and paint the sky using the 1in large stippler loaded with cobalt blue and titanium white. Next block in the shape of the mountain with the 1in flat brush using mixes of Payne's grey, burnt sienna, alizarin crimson, raw sienna and titanium white. Use a white water-soluble crayon to draw in the additional mountain structure.

Artist's Tip

The artist has used Liquitex Heavy Body acrylics and Keith Fenwick's brushes.

2. Following the guidelines for the mountain structure drawn in the previous stage, use the flat brush and mixes of Payne's grey, alizarin crimson and raw sienna to emphasize the rocky promontories and fissures of the mountain range. Then use the flat brush loaded with titanium white to paint the snow.

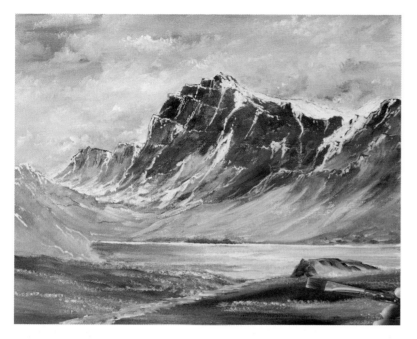

3. Paint the lake water using the 1in flat brush loaded with various tones of cobalt blue, Payne's grey and titanium white. Then paint the foreground with the large stippler loaded with mixes of Hooker's green, raw sienna, yellow orange azo, titanium white and vivid lime green.

4. Stipple the trees with the Ullswater brush and mixes of Hooker's green and vivid lime green. Add rocks in the foreground then finish the painting with some highlights. Landscape painting follows a theatre expression: design the set, arrange the elements and then light it.

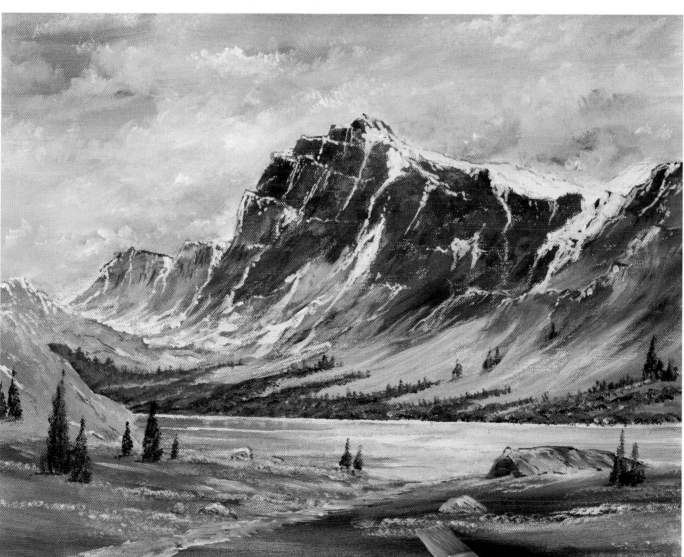

Freeing up colours with a black-and-white reference

Linda Matthews

When working from a black-and-white photograph, you will not be concerned with replicating exact colour, only tonal values (lights and darks), thus freeing up your imagination in terms of colour choice.

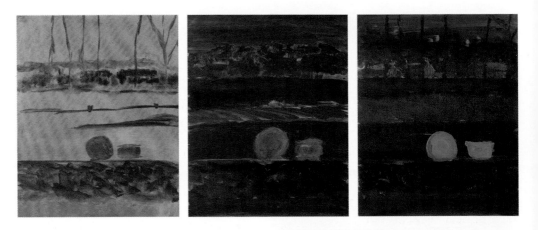

YOU WILL NEED:

Oils: burnt umber; Prussian blue; burnt sienna; permanent rose; cobalt blue; cadmium red; alizarin crimson; cerulean blue; Winsor yellow; lemon yellow; titanium white

Brushes: Size 12 long-handled flat; Size 6 long-handled round

Paper/support: oil paper, primed canvas or board

Other: black-and-white photo; purified linseed oil; oil paint dilutant or turpentine thinner

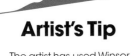

Artist's Tip

The artist has used Winsor & Newton oils and Zest-it oil paint dilutant.

1. First wash your chosen support with diluted burnt umber then start to map out your scene using undiluted burnt umber paint and your large brush. Paint dark underlayers to make the lights you later apply brighter; also, a common base colour visible through the spaces will knit the painting together.

2. Now block in the dark tones: burnt sienna and Prussian blue as the basis for a dark green background; permanent rose and cobalt blue for the dark purple mid and foreground; burnt sienna and cadmium red for the mid ground and houses; and alizarin crimson for the foreground wall. Apply the first layers of paint mixed with your chosen thinner then later layers with oil colours alone, a technique known as painting 'fat over lean'.

3. Next use a cerulean blue glaze on the sky then lighten your purple areas by applying titanium white. Lighten the red areas to orange with lemon yellow, then lighten the background houses. Using burnt umber, reapply the trees then use lemon yellow and burnt sienna to underpaint the pots.

4. With the round brush, gradually introduce titanium white as a means to lighten the tones and add highlights, thinking about where the light is coming from so you leave the shadows dark. Create the illusion of distance throughout the painting by using small brushmarks in the background and larger ones in the foreground for texture and contours.

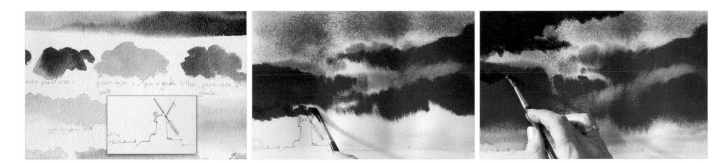

Painting a sunset with watercolour washes

Gwen Scott

Silhouettes of windmills or castles make interesting subjects to paint, especially if set against a dramatic, red sunset.

To create the strong vibrant colours in this sunset painting make sure that plenty of pigment is added to the initial washes.

YOU WILL NEED:

Watercolours: cobalt blue; ultramarine blue; rose madder; gamboge yellow

Brushes: Sizes 12, 6 and 1 rounds

Paper/support: 300gsm (140lb) watercolour, 28 x 19cm (11 x 7in)

1. Make a detailed outline drawing of the windmill at the bottom of the paper. Mix four washes for the sky: cobalt blue, rose madder, gamboge yellow and rose madder with gamboge yellow. Also make a strong, dark purple-black colour of ultramarine blue mixed with rose madder and gamboge yellow.

2. Wet the sky area thoroughly with a No. 12 brush. Then working quickly wet-in-wet with a No. 6 brush, paint the blue wash across the top of the paper, applying the washes of rose madder across the central area with some yellow-orange. Then add the gamboge yellow wash on the horizon.

3. Before the sky area dries, paint the purple-black wash in the top left-hand corner, reaching a little across the central area. Reinforce the rose madder wash if necessary, then leave to dry.

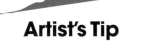

Artist's Tip

The artist has used Saunders Waterford watercolour paper.

4. Paint the silhouette of the windmill and foreground with the purple-black colour and the No. 6 brush, carefully keeping within the pencil outline. Finally, switch to a No. 1 brush to paint the windmill sails.

Using wet and dry pastels

Margaret Evans

Pastels continually inspire and excite me, whether they are used dry or wet. This Scottish landscape is a great example of how using a mix of dry pastels, wet pastels and watercolours can create really unique textures and allow the imagination to run free through the use of bold colour and style.

YOU WILL NEED:

Soft pastels: peach; white; pale blue; mid blue-grey; dark green; purple grey; orange; dark blue

Artists' watercolours: quinacridone gold; permanent rose; ultramarine blue; Prussian blue

Brushes: Size 10 round

Paper/support: sheet of white, sanded pastel board

Other: palette

1. On the pastel board, add liberal washes of quinacridone gold and permanent rose watercolours with the round brush; use just enough water in these washes for the colours to mix and run vertically, but not so much that it significantly dilutes the colour. On the lower half of the painting, drop ultramarine blue and more permanent rose to strengthen the tones, with a little Prussian blue.

2. Use the dark blue pastel to sketch in the composition, without being tempted to draw individual trees and details such as doors and windows. At this point you can alter the shapes without erasing by simply re-drawing where the first sketch will later be covered, for example on the distant mountains.

3. Add more watercolour paint with the round brush to strengthen colours, letting the pastel drawing melt with it. Now apply further details with dry pastel to adjust the tonal values, adding water to dilute where required. Pastel brands differ in the way they dilute: some will melt into pure paint while others will slightly resist, so enjoy the unexpected!

Artist's Tip

The artist has used an Art Spectrum pastel board.

4. When dry, adjust any colours with dry pastel by blending into the underpainting where a smooth finish is required, or by dragging across the land to create a misty texture. Use colours that inspire you and don't copy reality; this is much more fun and the exaggeration of hot colours helps to create the impression of summer heat.

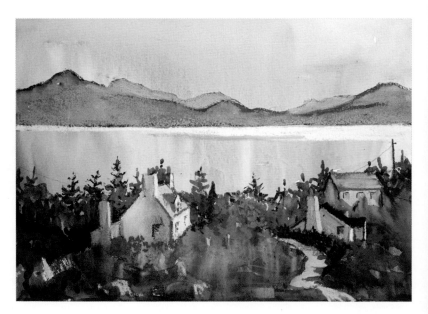

Painting loosely with oils

Mo Teeuw

Painting loosely is a matter of confidence, and with regular practice this will grow. My best advice is to prepare some small panels, use a limited palette with large brushes, then relax, play and enjoy. And most importantly, paint for yourself.

YOU WILL NEED:

Artists' oils: French ultramarine; cadmium yellow; permanent rose; oxide of chromium (green); alkyd white

Brushes: large hog hair; rigger

Paper/support: 35 x 46cm (14 x 18in) canvas

Other: turpentine

Artist's Tip

The artist has used Winsor & Newton alkyd white.

1. Working on a mid-toned canvas to help you judge your light and darks, first block in the shapes using a loose mix of ultramarine, permanent rose and a touch of cadmium yellow diluted with turpentine. Avoid detail at this stage and if using a photograph, make a tonal sketch first.

2. With a large hog hair brush, paint the sky and water using a mix of ultramarine blue, alkyd white and a touch of cadmium yellow, then use these colours and broad strokes to fill in the background.

Leave the original marks for the mast by painting up to the line.

3. Avoid using green straight from the tube, so alter as appropriate with blue, red, yellow and white. Look for tonal contrast to bring out shapes and be aware of edges, painting some hard ones to draw the eye. Blend in some of the background to soften and create unity. Working from dark to light, now add more detail on the boat, in the reeds and on the water.

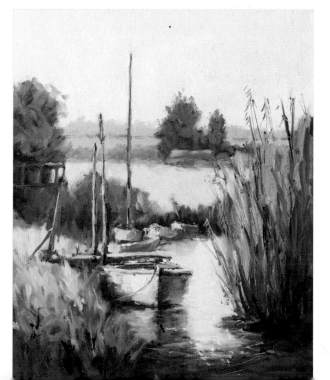

4. Finally, scumble the sky with a mix of permanent rose, yellow and white, adding touches of this colour throughout the piece to unify. Flick in final details and highlights with the rigger, using the end of the brush to soften edges and scratch in marks. Resist the temptation to fiddle.

Building an acrylic painting on a bright ground

Paul Apps

I seldom paint on a white surface, often opting to use a colour that is opposite to the overriding subject theme. The whole idea of this approach is two-fold: it provides a middle value colour on which to establish lights and darks at the very start of the painting process; and it creates an interest where small areas of the ground colour pop through. Here we'll throw caution to the wind and apply a very strong, bright colour – pure cadmium red light. Don't be in a rush to cover up the red; instead allow it to be seen so it unifies and harmonizes the finished painting.

YOU WILL NEED:

Acrylics: red; orange; cerulean blue; lemon; purple; ultramarine blue; white; Naples yellow; raw sienna; burnt sienna; cadmium red light

Brushes: ¾in wide flat brush; ¼in and ½in long flat synthetic brush; Size 2 rigger

Paper/support: 30 x 40cm (12 x 16in) canvas panel

Artist's Tip

The artist has used Daler-Rowney Graduate acrylics and SAA canvas.

1. Having selected your canvas and using a ¾in or above wide flat brush, combine your red and orange to create a lively red then paint this colour over the entire canvas. Next draw your subject outline using a violet hue to complete your initial sketch.

2. Using a ½in long flat synthetic brush throughout, mix cerulean blue with a touch of lemon to paint your sky and clouds. Follow this by painting the horizon in a series of mauves and violet blues. Allow the red ground to appear in sky areas you miss.

3. Now block in the cliffs using white, Naples yellow, red and raw sienna, including a darker value for the reflections. Alternate between ¼in and ½in long flat synthetic brushes. Paint the base of the chalk cliffs with darker greens, purple and burnt sienna. Add detail to the cliffs using violets and warm sienna mixes.

4. In this final, lengthy stage, apply many of the same colours throughout with a Size 2 rigger, merely altering the value in each as needed. Then add detail over the whole scene – watery blues, dark rocks and chalkstones across the sand. Finally, add the distant chalk cliffs and the grasses above each outcrop.

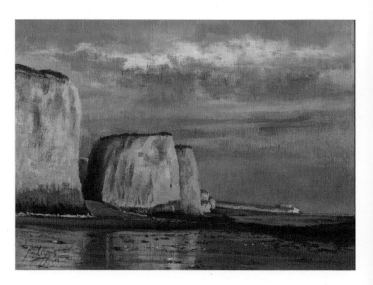

Spattering to add texture to a bridge scene

Paul Talbot-Greaves

This painting utilizes strong values and an extensive spattering technique. Use plenty of paint to generate strong values and ensure you properly fill your brush to spatter the paint; a sable brush is best for this technique.

YOU WILL NEED:

Artists' watercolours: Winsor lemon; cerulean blue; cobalt blue; yellow ochre; burnt sienna; viridian; Hooker's green; Winsor violet; ultramarine blue; cobalt turquoise

Gouache: white

Pencils/pens: soft pencil

Brushes: Sizes 6 and 4 squirrel mops; Kolinsky Sizes 14, 10, 8 and 4 rounds

Paper/support: 640gsm (300lb) watercolour rough

1. After using a pencil to draw the scene on the paper, loosely wash in some warm and cool colours with a Size 6 squirrel mop. Use Winsor lemon and cerulean blue in the top section then cobalt blue, yellow ochre and burnt sienna lower down. Leave the top of the bridge in direct sunlight as pure white.

2. Use a scrubbing technique with the Size 4 mop brush to paint the trees in various mixes of Winsor lemon, viridian and Hooker's green. While these are still damp, add the darks and trunks in Hooker's green and Winsor violet with a Size 4 round then spatter some of the lighter green mix into the area with a Size 8 round to create texture.

3. Using a Size 14 round, paint the dark sides of the bridge with strong mixtures of ultramarine blue, yellow ochre and burnt sienna, incorporating even stronger values made from ultramarine blue, burnt sienna and Winsor violet for the deep shadow areas. Add cobalt turquoise in places then spatter clean water into the wash with a Size 8 round brush.

4. Finally, reinforce the dark values on the bridge and suggest some stone shapes with a Size 10 round. Spatter more green into the trees with a Size 4 round then add more texture to the bridge by spattering it with a Size 8 round and a mix of cobalt turquoise, yellow ochre and white gouache during various stages of drying

Using a teaspoon to paint a snow scene

Paul Beattie

When painting with spoons, I always work wet-in-wet; this helps to mix and blend the colours. Try not to overmix your paint to one flat colour wherever possible; if you mix to leave slight variations of colour, the paint will do the work and add some details for you.

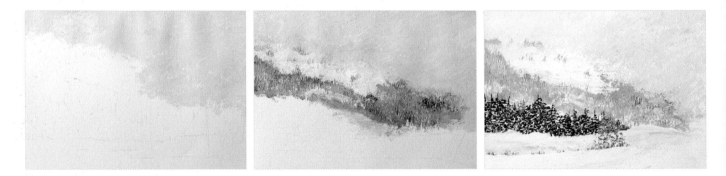

YOU WILL NEED:

Acrylics: ultramarine blue; titanium white; buff white or unbleached white; yellow ochre; burnt umber; cadmium yellow hue; red oxide

Paper/support: watercolour block NOT surface

Other: teaspoon; acrylic palette; old rag or t-shirt for wiping spoon (do not use soft kitchen towel)

Photograph reference kindly provided by Mr Ralph Mims

1. Create a light mix of ultramarine blue and titanium white in your palette with the base of the teaspoon. Working from right to left, apply the paint for the winter sky with the underside of the spoon, creating subtle colour changes. Dab and pull some small sections of sky area, blending as needed.

2. Now create a grey-black using ultramarine blue and burnt umber, then use it to paint the mountains and forest. Mix the sky colour with more white and apply along the top of this area, blending into the sky as you work. Then use cadmium yellow and a little red oxide to introduce bright hints of distant

birch trees on the hillside. Use the side of the spoon to drag the paint upwards. creating the suggestion of treelines.

3. Use ultramarine blue and yellow ochre to mix a dark green and use this to paint the mid to foreground fir trees. With the under tip of the spoon, create the tree shapes then use the spoon edge to create the tree tops. Apply cadmium yellow and red oxide to create some bright grasses and a bush in the mid ground. Leave to dry, then paint snow on the trees, grass and bushes using titanium white with a touch of ultramarine blue for the shadows.

Artist's Tip

The artist has used Liquitex acrylics and Langton watercolour block paper.

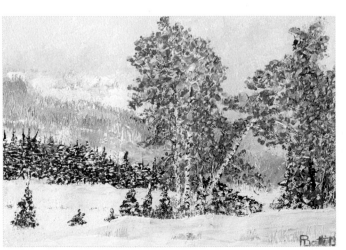

4. In the foreground, use the teaspoon to create small evergreens with a lighter green. Add some greys to the background of the main trees then introduce some bushes and tree trunks. Use white and buff white to paint the birch trees, dabbing on black highlights. With the tip of the spoon, create foliage using cadmium yellow with red oxide.

Linking a composition with puddles

Peter Woolley

In watercolour, we should always be looking for ways to link separate areas of our compositions together. In particular, we should try to avoid the top/bottom, 50/50 split, where colours in one half of a painting are isolated from the other half. Puddles provide us with a perfect solution to the problem, with the excuse to disperse colours from the sky into other areas of the composition.

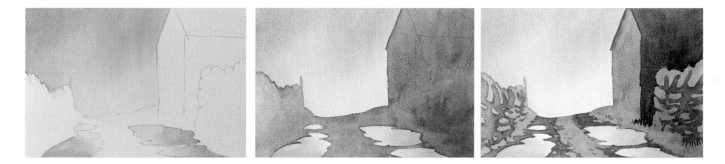

YOU WILL NEED:

Artists' watercolours: cadmium yellow; cadmium red; French ultramarine; burnt umber

Pencils/pens: 2B pencil

Brushes: 1in flat wash; Sizes 16, 10, 4 and 2 rounds

Paper/support: watercolour

1. After drawing the scene out lightly in 2B pencil, apply a wet-in-wet wash of cadmium yellow, cadmium red and French ultramarine to the sky using the 1in wash brush. Try working with your board set at an angle of 25 to 30 degrees; this encourages the washes to flow downwards and mix. Repeat the wash in the puddle areas, only in reverse. Leave to dry.

2. Apply a dark grey, mixed with French ultramarine and burnt umber, to all the remaining areas of the painting using the Size 16 round brush; this makes the sky appear much lighter and enhances its glow. Try to achieve a smooth, even finish but this is not compulsory; any anomalies in the wash will simply add texture, which is not entirely unwelcome.

3. Using the Size 10 round, create a slightly darker version of the French ultramarine and burnt umber mix then use this to break down the grey areas to provide the building with form, suggesting a few individual stone details in the walls. Paint in the track with burnt umber, roughing up the edges as you do so to suggest rocks and cracks.

Note how a dark tone applied to the facing edges of the puddles helps to provide them with a little depth. It's very important to apply these dark tones to facing edges only and not around the entire shape, otherwise they'll just look outlined and unnatural.

4. Now alternate between Size 4 and Size 2 rounds to add further details to the walls and building, using a darker version of the French ultramarine and burnt umber mix. Don't paint every detail of the wall – less is definitely more. Complete the scene by adding a couple of simple figures with the grey mix and a drop of cadmium red. Again, repeat in the reflections.

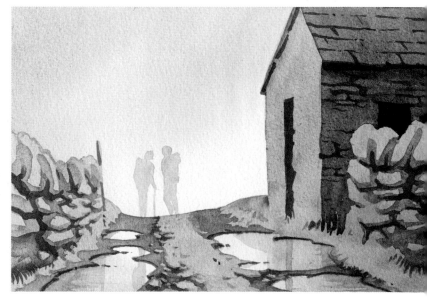

Using layers to create depth

Richard Holland

I try to paint scenes local to where I live; this enables me to make many small studies and watercolour sketches before I embark on my final oil. After drawing out this run down stone barn, you will discover how applying a tonal underpainting then progressively building up the painting from the darker tones to the lightest ones will provide real depth and interest.

YOU WILL NEED:

Artists' oils: burnt sienna; French ultramarine; white; green gold; cobalt blue; cerulean blue; lemon yellow; cadmium yellow; Naples yellow; yellow ochre; alizarin crimson; cadmium red; burnt umber; raw sienna; jaune brilliant; Davy's grey; buff titanium

Pencils/pens: HB pencil; soft pencil for smudging

Brushes: Sizes 2, 4 and 6 flat oils; Sizes 2, 4 and 6 oil filberts

Paper/support: canvas board

Other: thinner

1. Draw in the main subject with the HB pencil, very roughly marking smaller details that may get covered with the underpainting. Then use a softer pencil for shading the darker areas.

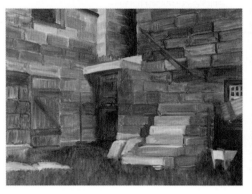

2. Now use burnt sienna, French ultramarine and white with thinners to underpaint your canvas for a tonal base. Use burnt sienna for the mid-tones, adding progressive amounts of French ultramarine for the darker areas then progressive amounts of white for the lighter ones. Some of these darker colours will be visible in the final painting. Leave to dry.

3. Next start adding colour – French ultramarine, cobalt blue, cerulean blue, lemon yellow, cadmium yellow, Naples yellow, yellow ochre, alizarin crimson, cadmium red, plus the earthy colour of burnt umber and raw sienna – using neater, thicker paint that is slightly darker than the final result. Still block the colours in at this stage, avoiding large amounts of detail and allowing some of the underpaint colour to show through.

4. Finally paint the last layers of detail and texture, using thick paint without thinner. At this stage it should be nearly all highlights, adding these against the darker areas. Use the same palette, adding some new colours to liven it up – green gold and jaune brilliant for the grass, with Davy's grey and buff titanium for stonework. Continue to apply layers until the painting feels right.

Painting the same subject in different seasons

Steve Hall

How often do we hear people say 'I don't know what to paint'? Actually we are surrounded by subjects and, as these examples show, often the same scene at different times of the year or in different weather conditions, can provide endless opportunities.

YOU WILL NEED:

Watercolours: light red; ultramarine blue; raw sienna; burnt sienna; burnt umber; cadmium yellow

Brushes: large mop; Size 8 detail; Size 6 rigger

Paper/support: 300gsm (140lb) NOT watercolour

1. I have produced a watercolour sketch of the Silent Pool near Guildford in Surrey. It represents a summer's day with good sunlight and the trees in full foliage. The interesting subject offers endless possibilities for further work if we consider a different sky or perhaps a change of season.

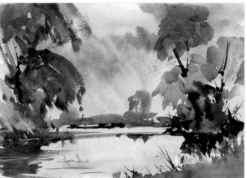

2. Here we have the same time of year but with the threat of a thunderstorm. The darkening sky has changed the bright greens to more sombre tones, with a cloud shadow across the distant hills and tree. This darkening of the landscape counterchanges with the pond to make the water appear much brighter than in the previous example.

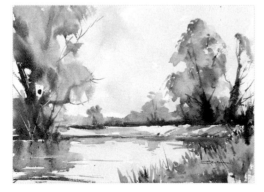

3. Now we move into autumn and the whole scene is changed by the colours of this season. Some of the trees have lost their foliage and this effect has been achieved by dragging the paint quickly across the rough paper. Note also how the general colour scheme has been echoed in the sky.

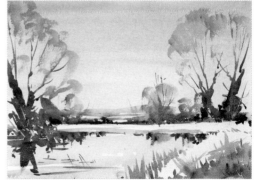

4. Finally we view the scene in winter. The leaves are gone, leaving the trees in skeletal form. A quiet sky enhances the starkness of the trees and brings a feeling of bleakness to the scene. Quick, downward strokes with the mop brush are used to describe the twig pattern at the end of the branches.

Achieving realistic skies

Steve Williams

Cloudy skies are one of my most enjoyable subjects, and I can achieve a simple, realistic effect by using the side of my brush and allowing the slightly splayed bristles to create fantastic cloud edges. A simple landscape under a well-painted sky will always bring the viewer into the painting and provide pleasure with every viewing.

YOU WILL NEED:

Artists' acrylics: titanium white; cobalt blue; burnt umber; burnt sienna; Naples yellow

Brushes: No. 16 round acrylic

Paper/support: stretched canvas or heavy watercolour paper

1. Prepare a pale, blue-grey mix made from titanium white, cobalt blue with a little burnt umber then paint in the whole surface area using the No. 16 round brush.

2. Next paint the blue areas of the sky with a mix of titanium white and cobalt blue. Add a little more cobalt to the top section, allowing the blue in the lower section to remain slightly lighter, thus creating distance. Then using the side of the brush, scrub in the first clouds with titanium white.

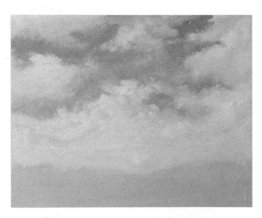

3. Now create further distance by painting Naples yellow and titanium white on the horizon, fading it into the cloud mass above. Follow with an application of titanium white to enhance the clouds, ensuring that some greyer white is retained as shadow areas.

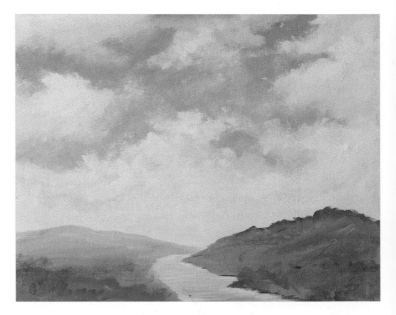

4. Paint the hills with cobalt blue, burnt sienna and titanium white, adding more titanium white to the far left-hand hill to create distance. Apply titanium white, cobalt blue and a little Naples yellow for the river, adding white at the bend. To complete, apply further detail to the river with cobalt blue and titanium white, using horizontal brushmarks.

Creating a contemporary impressionistic style

Sue Townsend

Painting lavender fields in Provence can be evocative and challenging. The perspective of the lavender rows brings impact to the picture, and the blues and magentas reflect the various tones of the flowers. The smell of lavender in the heat of the day is intoxicating and this sense is reflected in the overall composition, colour and tone of the painting.

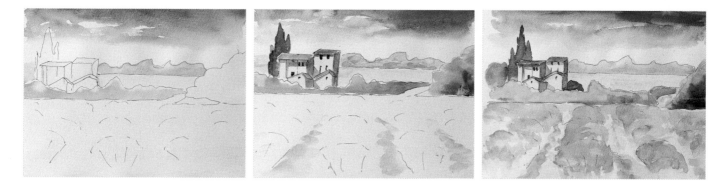

YOU WILL NEED:

Artists' watercolours: Winsor violet; cerulean blue; cobalt blue; lemon yellow; yellow ochre; light red; magenta

Pencils/pens: soft pencil or waterproof pen

Brushes: Kolinsky Sizes 12, 8 and 6 rounds

Paper/support: watercolour

1. In pencil or waterproof pen, very simply sketch the outline of the houses and trees, lightly indicating the rows of lavender that radiate out and fade into the distance in perspective. Then use a light wash of cerulean blue to paint the sky with the Size 12 brush, followed by a wash of yellow ochre for the houses and the far field. Leave to dry.

2. With the Size 8 brush, use cerulean blue and yellow ochre to paint the dark trees on the left behind the houses then paint the other trees and hedges with a light mix of lemon yellow and cobalt

blue. Paint the roofs of the houses in light red then use a blue wash of cobalt for the shadow sides of the houses and windows. Add in the foreground paths using yellow ochre, remembering to maintain the perspective.

3. Next use a light mix of magenta and cobalt blue (or violet) to paint the rows of lavender, leaving space for the paths between them. While this application is still damp, drop a green mix of cerulean blue and yellow ochre in front of the rows and along their shadow sides. Leave to dry.

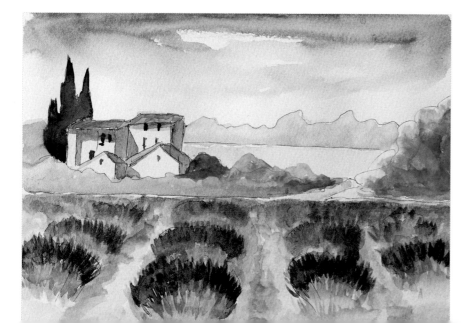

4. Use Winsor violet and small brushstrokes with the Size 6 brush to indicate the spikes of lavender as they spray out then paint the paths with yellow ochre. When dry, paint in the lavender stems, gradually adding more lavender rows while taking care to paint the shadows on the same side.

Abstract

Painting an abstract with acrylics

Helen Kaminsky

When creating abstracts, I find it crucial to create a strong composition, as this will provide the piece with a tangible start and solid foundation on which to work. Here I have chosen a cruciform composition, which is based on a cross with a strong focal point in the form of a zigzag to introduce tension among the elements.

YOU WILL NEED:

Acrylics: ultramarine blue (red shade); cadmium yellow; cadmium red; phthalocyanine green; titanium white; Prussian blue; naphtol red

Acrylic inks: red; blue

Oil pastels: red; blue

Pencils/pens: watercolour pencil

Brushes: ½in and 1in flat acrylics

Paper/support: 40.6 x 30.8cm (16 x 12in) canvas board

Other: resin sand; light moulding paste; glazing liquid; palette knife; stencil (such as garden netting or pizza tray base); tissue paper; PVA glue; kitchen towel; spray bottle; bottle top; toothbrush

Artist's Tip

The artist has used Liquitex Heavy Body acrylics, Liquitex acrylic inks, Daler-Rowney System 3 brushes, Paperwave artists' canvas board, Liquitex resin sand and Winsor & Newton glazing liquid.

1. Map out your cruciform composition with the watercolour pencil. Using a palette knife, apply resin sand to create the shape on the left and light moulding paste through a stencil on the upper right-hand side. Adhere tissue paper to the lower right-hand side with PVA glue.

2. Now spray the board lightly with water and use a damp kitchen towel to apply blocks of bright paint colours, as shown. This method of paint application is fast and spontaneous, bringing energy to the piece.

3. Using an ultramarine blue wash, soften the upper red area and darken the blue; also tone down the yellow with a wash of titanium white. Then mix phthalocyanine green with glazing liquid and apply with a 1in brush in one direction throughout the main cruciform shape, overlapping the other colours slightly.

4. Create shapes of interest with oil pastels then use the 1in brush and inks to apply red squares and blue lines. Using the bottle top, stamp white circles to create a focal point then highlight with a pastel zigzag. To finish, spatter titanium white mixed to a consistency similar to single cream over the piece with the toothbrush.

Using acrylics to mimic oils

Fraser Scarfe

Acrylics are an excellent medium for those starting out in painting: they dry fast, are easy to alter and don't make a mess. Moreover, thanks to recent advances in quality, acrylics are now able to match oils in terms of workability and finish. The Atelier Interactive range of acrylics are formulated to offer the artist much more freedom than conventional acrylics, allowing you to control the drying time of your paint and to rework paint even after it has dried. By using Atelier Interactive acrylics and a range of mediums, artists can now easily achieve the appearance of oils in their work.

YOU WILL NEED:

Acrylics: titanium white; yellow ochre; burnt umber; Payne's grey; ultramarine blue; Naples yellow

Brushes: Size 20 and 12 rounds; Size 10 and 8 flats; 1in blender

Paper/support: canvas board

Other: palette knife; impasto gel; clear painting medium; gloss medium; gloss varnish

Artist's Tip

The artist has used Atelier Interactive acrylics, Atelier brushes, and Atelier impasto gel, painting medium, gloss medium and gloss varnish.

1. The slower drying time of oils allows more blending and smoother colour transitions, but using Atelier Interactive acrylics will increase your working time, thus allowing you to achieve similar results. Using a retarder medium with acrylics will also increase working time.

2. Mix a clear painting medium with your acrylics as you work so you can smoothly dilute your paint without losing sheen levels. This helps your colour remain more vibrant and also allows you to spend more time achieving smoother and more sophisticated blended transitions between colours.

3. Oil paint is excellent for working with impasto techniques to build texture in paintings. Mix an impasto gel with your acrylics to achieve similar effects: to provide your paint with more body and allow you to use a palette knife to create texture in your work.

4. The glossy sheen of oils can be easily achieved with acrylics by mixing small amounts of gloss medium with your paint as you work. It is also important to glaze any finished works with several thin coats of gloss varnish, as this protects the work and brings colours an extra depth and richness.

Printing with a lino block

Jacqui Petrie

The way an image changes through the process of printmaking is inspirational to me. Simplify colour to black and white and use interesting textures for tone in order to see your work a different way.

YOU WILL NEED:

Pencils/pens: biro; permanent marker

Paper/support: suitable for printing

Other: tracing paper; all-in-one block printing kit; old rag; spoon; image or photograph of your choice

Artist's Tip

The artist has used a Speedball all-in-one block printing kit.

1. First, trace around your lino block – this will establish the size of the block on the tracing paper to create a frame for your image tracing – then trace your image within these lino block borders. Now place the image face down on the lino block and use a coloured biro to transfer the design, which will be reversed. Work over the biro with permanent marker, blocking in the solid areas and detail you require in the print.

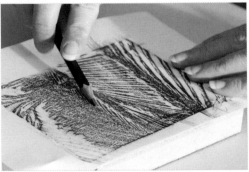

2. Always keeping your hand behind the blade, first cut around the large shapes with the smallest cutter to achieve neat edges. Cut out all the unmarked areas, remembering that what you cut away will not print. As you progress, from time to time lay a piece of thin paper over the block and take rubbings to see what your print will look like.

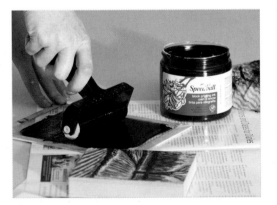

3. Organize your work area with an ink tray or glass, ink, a roller, paper cut to size, an old rag and somewhere to put the wet prints; then squeeze a marble-sized blob of ink onto the ink tray or glass. Evenly roll this out vertically and horizontally the width of the roller only, listening for a gentle hiss, which indicates the ink layer is even.

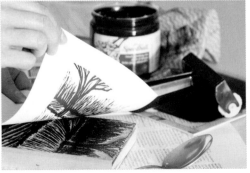

4. Roll the ink evenly onto the block then lower your paper onto its top edge. Carefully and lightly press the paper down the block with the heel of your hand: the ink will grip the paper and produce a light print. To create a perfect dark print, burnish the back of the paper on the inked block with the back of a spoon and ensure that you re-ink for every print.

Working with washes and collage

Jan Gardner

Here I'll provide an insight into the way I use loose washes and contrast to develop atmosphere in my work; I also like to introduce depth with collage, and detail with pen work. The vibrant colour is a special palette that I frequently use – explore and enjoy!

YOU WILL NEED:

Acrylic inks: quinacridone magenta; deep violet; phthalo green; yellow orange azo; naphthol crimson; titanium white; emerald green; process cyan

Artists' watercolours: ultramarine blue; violet blue; yellow light; opera rose; titanium white

Pencils/pens: sketch-pen

Brushes: Large Detailer Size 4; Detailer Size 2; Easy Flat 1in; Flatmate ½in

Paper/support: 640gsm (300lb) rough watercolour; bamboo paper, painted for collage

Other: blue masking fluid; PVA glue

Artist's Tip

The artist has used Liquitex and Daler-Rowney acrylic inks, Sennelier Aqurelle watercolours, a Speedball sketch-pen, SAA brushes, Arches Aquarelle rough watercolour paper, Hahnemühle bamboo paper and Schmincke blue masking fluid.

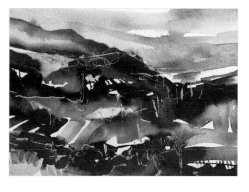

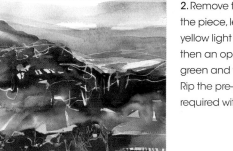

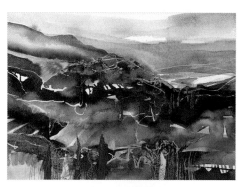

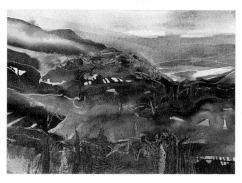

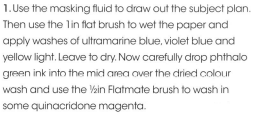

1. Use the masking fluid to draw out the subject plan. Then use the 1in flat brush to wet the paper and apply washes of ultramarine blue, violet blue and yellow light. Leave to dry. Now carefully drop phthalo green ink into the mid area over the dried colour wash and use the ½in Flatmate brush to wash in some quinacridone magenta.

2. Remove the dry masking fluid from the top half of the piece, leaving some in the lower areas. Paint a yellow light wash across the horizon and mid area then an opera rose wash for the sky. Add phthalo green and yellow orange azo ink to the foreground. Rip the pre-painted collage paper, and stick it where required with PVA glue.

3. Remove the remaining masking fluid then draw foliage and lines using the sketch-pen and deep violet ink. Mix titanium white and blue violet watercolours then use the Size 2 detailer to paint the distant rocks on collage paper. In the foreground, add more foliage and grass using the sketch-pen with naphthol crimson and emerald green ink. Add foreground collage paper then draw fern and grass shapes with process cyan ink.

4. Finally mix quinacridone magenta, deep violet and titanium white ink to paint the background using the flat brush. Then use the detailer to wash yellow orange azo onto the areas of focus, rocks and foliage. With the sketch-pen, draw onto the collage areas with process cyan, picking out the detail. To complete, wash ultramarine blue into the sky with a flat brush.

Preparing cradled gesso surfaces

Malcolm Cudmore

Coloured pencils are a waxy, slightly adhesive medium that work well on surfaces other than paper. I regularly work on 'cradled' 6mm (¼in) MDF panels, prepared with several coats of white acrylic gesso and sanded to a smooth surface. In this way, finished work can be presented just like acrylic or oil paintings.

YOU WILL NEED:

Materials: 6mm (¼in) MDF sheet; planed timber measuring approximately 1.5 x 3cm (½ x 1¼in) for the cradle; PVA wood glue; 2cm (¾in) copper nails; fine surface wood filler; fine sandpaper; white acrylic gesso; coloured pencils of your choice; erasers and any other personal coloured pencil equipment; spray matt artists' quality varnish

Tools: wood saw; hammer and nail punch; framer's mitre saw or 45-degree mitre box; brush, paint roller or plastic squeegee

1. Cut the MDF panel to size and, if required, prepare the cradle. For small panels, you could use 9mm (⅜in) or 12mm (½in) MDF without further support, although larger panels – my largest so far has measured 122 x 91cm (48 x 36in) – can be quite heavy. The cradle prevents thinner panels from warping when painted.

2. Glue the cradle with PVA wood glue then pin it with copper nails (to prevent the rust from coming through) to the rear of the panel. Countersink the nail heads with a nail punch and fill the holes with fine surface wood filler. Then sand the panel flat.

3. Apply a minimum of six coats of white acrylic gesso to the panel. The gesso can be brushed, rolled or applied with a plastic squeegee; for a really smooth surface, sand between coats. It's advisable to seal the back of larger panels to protect them from warping due to moisture.

4. Most coloured pencil techniques can be used on these panels, building up lightly applied layers of colour and value. Electric erasers and scalpel blades are perfect for removing or modifying your marks. Finish your picture by painting the edges, varnishing and framing; it will not require mounting under glass.

Flowers, Trees & Gardens

Painting a colourful, loose tree

Andrew Geeson

I love using this loose wet-in-wet technique because it allows me to capture the mood and feeling of a tree, far beyond just a pictorial representation. Quick, immediate and exciting is how I would sum up my approach to watercolours – have a go yourself, you may feel the same!

YOU WILL NEED:

Artists' watercolours: lemon yellow; gold ochre; cerulean blue; sap green; perylene green; Winsor violet; indigo; burnt umber

Pencils/pens: 2B pencil

Brushes: Size 16; rigger

Paper/support: watercolour

Other: soft tissues

1. With the 2B pencil, first produce a simple, loose drawing of the tree on the sloping bank, keeping the line work as loose as possible. Create a simple triangular shape for the tree canopy, with a curved trunk reaching into the bank.

2. With the large Size 16 brush, apply clean water in random blobs to the sky and middle background areas then drop lemon yellow and cerulean blue into these wet areas. Next apply clean water to the bank area, retaining white paper as gaps of light. Immediately drop gold ochre, cerulean blue, Winsor violet and indigo colours into these wet areas.

3. Still using the Size 16 brush, add large blobs of clean water all over the tree canopy area, then drop lemon, yellow, gold ochre, cerulean blue, sap green, perylene green and Winsor violet into these wet areas, allowing the colours to merge – again, leave white paper to represent gaps of light. Add and remove pigment with a clean tissue to create areas of contrast or mist.

4. Now using the rigger, apply clean water to the trunk area. Drop in gold ochre, burnt umber, Winsor violet and indigo from light to dark, allowing the colours to fuse with the damp paint areas surrounding it. Finally add detail to the bank to create rocks and in the tree canopy to create areas of leaves.

Creating a realistic tree structure

Carol White

Many new painters have difficulty painting trees, yet a vital part of learning to recreate them on paper is observation. Moreover efficient, confident brushstrokes are essential and here I've described how to use the brushes for trees. Push rather than drag your rigger and lighten the pressure of your round brush as you approach the end of a branch, which should be painted in the direction of growth.

YOU WILL NEED:

Watercolours: yellow ochre; ultramarine blue; burnt sienna

Brushes: Size 8 or 10 round; Size 2 or 3 rigger

Paper/support: 300gsm (140lb) watercolour

Artist's Tip

The artist has used Saunders Waterford watercolour paper.

1. Practice the different stages, as confidence will create freer brushstrokes. Don't grip the brushes too tightly or too near the tip, as this will cause rigidity. On a piece of rough paper, paint a couple of branches at a time, working wet-in-wet. Try experimenting with different colours; the ones used here are only some of many options.

2. To start working on a single tree, use a round brush to paint the trunk with a weak mix of yellow ochre. While still wet, drop thicker mixes of yellow ochre and ultramarine blue, then ultramarine blue and burnt sienna, from the tip of the round brush on one side of the trunk. Introduce highlights on the other side by pushing the paint back towards the dark side with a damp round brush.

3. Continue working as before, now with a strong mix of burnt sienna and ultramarine blue. Try catching the dry paper with your brush to create a rough tree edge. Add more branches, always painting them in the direction of their growth. Start and follow through an existing branch before growing out a new one.

4. Using your rigger, add smaller branches with variations of the ultramarine blue and burnt sienna mixes. Try placing the tip of the brush down and pushing rather than dragging it, so the brush springs across the surface. Add a few dry brushmarks with the rigger to bring texture to the finished trunk.

Using acrylics on black pastel paper

Geraldine Patey

I like to paint oil on velour paper and wanted to teach this technique to my students. However each application of paint needs to dry before applying the next, which takes too long with oil paint, so I looked at trying acrylics instead on Hahnemühle black velour pastel paper. When using this technique, remember to leave some black spaces and don't overpaint. Experiment, use your imagination and enjoy!

YOU WILL NEED:

Acrylics: cadmium orange; cadmium yellow light; permanent sap green; olive green; copper; gold; silver

Pencils/pens: B pencil

Brushes: Size 00 round acrylic; Size 00 acrylic filbert

Paper/support: black velour pastel

Other: Tracedown in white; stay-wet palette

Artist's Tip

The artist has used Atelier Interactive acrylics and Hahnemühle black velour pastel paper.

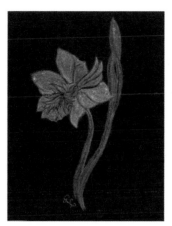
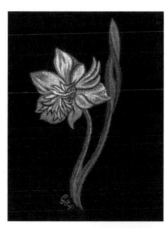
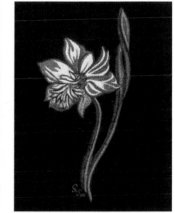
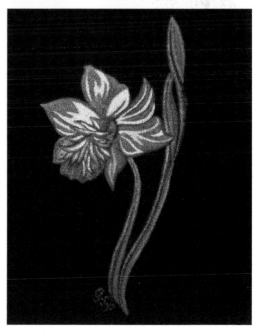

1. Trace a simple outline drawing onto the velour paper then apply a small amount of paint to the tip of your filbert brush to sweep across the surface. Apply a mix of cadmium orange and cadmium yellow light to the flower trumpet and petals. Then apply sap green to the leaves and stem, followed by olive green. Leave to dry.

2. Repeat this process, one layer at a time, using a mix of cadmium yellow light and sap green to lighten the edges of the leaves and stem. Leave to dry.

3. Apply the cadmium orange again to the petals then use it to outline part of the trumpet. Apply a mix of cadmium yellow light with cadmium orange to some of the less yellow areas and to cover some of the traced lines. Paint another layer on the leaves and stem to create more contrast for shading.

4. Create further areas of contrast to represent shading then with the round brush, add highlights to the whole image using mixes of copper with cadmium orange, gold with cadmium yellow light, and silver with olive green. Paint copper lines on the trumpet: fewer layers will produce darker shades, while more layers will produce brighter and more intense colours.

Creating depth and distance in a meadow of poppies

Claire Warner

I wanted to remember the wonderful days of my childhood when we had beautiful meadows of wild flowers. Here the out-of-focus background gradually increases in clarity and vibrancy to the foreground as the painting progresses, creating depth and distance.

YOU WILL NEED:

Artists' watercolours:
lemon yellow; rose madder; cadmium red; burnt sienna; ultramarine blue; cobalt blue

Pencils/pens: ruling pen; soft pencil

Brushes: Silver Flat 1in; Silver All-Rounder Size 10; Silver Worker Size 6; Detailer Size 2

Paper/support: 638gsm (300lb) heavyweight watercolour

Other: masking fluid; pipette; muffin tray palette; rectangle plastic palette; fine mist spray

Artist's Tip

The artist has used SAA watercolours, SAA brushes, Saunders Waterford watercolour paper and SAA Blue Mask masking fluid.

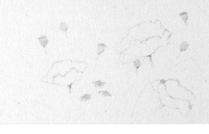

1. Lightly draw three large poppies on your paper with the pencil; a main one and two slightly smaller poppies to support it, taking care to avoid the two-eyes-and-a-nose look; also draw the seed heads and daisies. Pay particular attention to the placement of all these flowers.

2. Mask around the poppies, ensuring that you don't leave any gaps; this will provide a clean, sharp edge when it is removed. Also mask the daisies, poppy heads and seeds, being precise in your work to achieve a distinct, hard edge. Leave all the masking fluid to dry thoroughly.

3. Next wet the paper thoroughly, although not inside the masked poppies. Apply cobalt blue for the sky and cadmium red for the out-of-focus poppy shapes. Mix various shades of green from the lemon yellow and ultramarine blue then paint the leaves, foliage and stems with light, mid and dark colours. Repeat above with stronger pigment for the mid ground, using the mist spray to keep the paper moist. Leave to dry.

4. When the paper has dried completely, remove the mask. Use cadmium red to apply a watery wash over the poppies, painting a stronger wash of cadmium red towards their centres and adding a black mix of ultramarine blue and burnt sienna whilst still damp, although not wet. Paint the poppy heads with a green mix of lemon yellow and ultramarine, using the darker mix on the shaded side, with a purple top. Add in final details such as the daisy centres and purple seed heads.

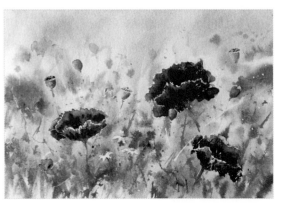

Applying salt to create texture in watercolour paintings

Deborah Burrow

This is one of my favourite ways to create texture and interest in a watercolour painting. Applying salt to wet paint for special effects is fun and inspiring. The salt crystals soak up pigment from the paper to leave behind all sorts of shapes that describe foliage very well, and also textures for fruit, flowers and more.

YOU WILL NEED:

Artists' watercolours: Indian yellow; olive green; French ultramarine; burnt sienna

Brushes: watercolour sable; Size 4 round or rigger

Paper/support: 300gsm (140lb) NOT watercolour

Other: sea salt flakes

1. Blend Indian yellow, olive green and French ultramarine on the paper wet-in-wet. In general this technique can only be done once to an area of paper, so test out your colour mixes first.

2. While the paint is still wet, rub sea salt flakes gently between your thumb and forefinger straight onto the painting. Smaller grains of salt will create smaller shapes.

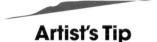

Artist's Tip

The artist has used Winsor & Newton artists' watercolours, Winsor & Newton brushes and Bockingford watercolour paper.

I recommend using a good quality paper. Bockingford NOT 300gsm (140lb) watercolour paper is excellent for this technique but it works well on smooth paper, too. I have also found that the darker the paint, the more dramatic the effects.

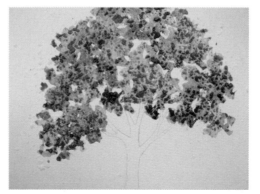

3. When you have completed the crown of the tree leave to dry naturally, so the salt has the maximum time to work its magic. Once the paint and salt has dried, gently rub off the salt with your fingertips. If there are any stubborn areas, use an old plastic card to gently scrape the salt off.

4. When the salt has been removed it will reveal the suggestion of leaves. To finish, paint the tree trunk and branches using a mix of burnt sienna and French ultramarine then whilst damp, drop in French ultramarine to create shadow areas.

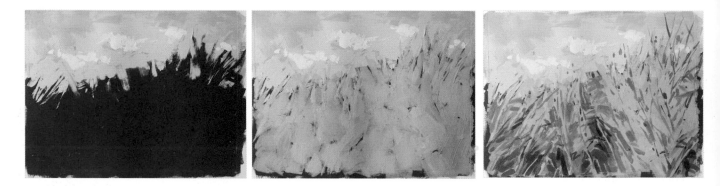

Underpainting with complementary colours

Haidee-Jo Summers

An effective way to create interest and vibrancy in an acrylic painting is to build up the piece in layers. In this instance, I underpaint the main subject with complementary colours then allow those colours to show through in little gaps here and there throughout the painting.

YOU WILL NEED:

Artists' acrylics: titanium white; azo yellow deep; azo yellow; cadmium red light; alizarin crimson; cerulean blue; ultramarine blue; raw sienna

Brushes: Sizes 02 and 20 acrylic filberts; Size 10 flat acrylic

Paper/support: acrylic

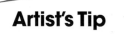

Artist's Tip

The artist has used Winsor & Newton artists' acrylics, SAA brushes and Clairefontaine acrylic paper.

1. Simplify the subject into major shapes: covering the whole paper surface, underpaint the sky area in orange using a mix of azo yellow deep and cadmium red light then the field area in alizarin crimson, using paint straight from the tube without adding water and the Size 20 filbert. Allow the underpainting to dry fully. Then paint the blue sky using cerulean blue, titanium white and alizarin crimson, allowing flecks of the orange underpainting to show through.

2. Now mix greens from azo yellow deep with cerulean blue and raw sienna then use the Size 02 brush to do the same with the midtoned greens on the grasses, allowing your brushstrokes to follow the direction of growth.

3. Build up the darker greens in the meadow grasses, which lend more definition to the foreground. With a couple of strokes of the Size 02 brush, using mainly cadmium red light and a little alizarin crimson here and there, start to paint the poppy flowers.

4. To finish, add the larger poppy flowers, as well as a few smaller details, such as the brighter greens of some stems. It is important to leave parts of the underpainting colours to show through here and there, so that they can impart vibrancy to the finished piece.

Using blotting paper to paint flower petals

Jill Bays

Texture and freshness are things that many artists struggle to bring to flower painting, yet the subject demands them to capture the essence of a bloom. By exploring different methods of painting, you will discover new tools to help you recapture that lost sparkle. In this case, using blotting paper to create petals by lifting out shapes and tone will bring out the freshness and texture of the hydrangea.

YOU WILL NEED:

Artists' watercolours:
ultramarine blue; permanent rose; Winsor yellow; Winsor violet

Pencils/pens: 2B pencil

Brushes: Nos 8 and 12 rounds

Paper/support: 300gsm (140lb) NOT watercolour

Other: blotting paper, scissors

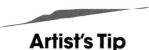

Artist's Tip

The artist has used Winsor & Newton artists' watercolours.

1. First draw the shape of the hydrangea using your 2B pencil. Draw lightly and avoid erasing if possible.

2. Dampen the flower shape with water then drop in a pale wash of permanent rose using the No. 12 brush. Mix a grey from permanent rose, ultramarine blue and Winsor yellow then use this to apply a darker wash to the right-hand side. Cut out petal shapes from the blotting paper and blot out some lighter toned petals. Then drop in a few specks of pure permanent rose for the flower centres.

3. Use your grey mix and Winsor violet to define the petals. Add further detail with the smaller No. 8 brush, as well as the flower centres.

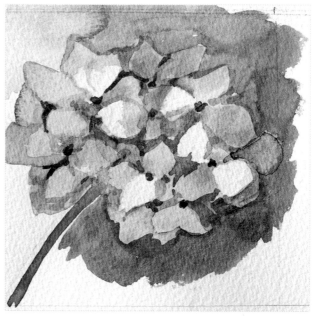

4. Mix ultramarine blue and Winsor yellow to make a green then add the stem. Strengthen the colours if necessary then paint a background of leaves or shadow to define the flower, working freely and lightly.

Painting white flowers

Julie King

White flowers evoke purity, elegance and beauty. Painting a white flower is often seen as the most challenging of floral subjects, yet if you follow a few simple steps the results can be simple, but very effective.

YOU WILL NEED:

Artists' watercolours: aureolin; new gamboge; cobalt blue; burnt sienna

Pencils/pens: B pencil

Brushes: Size 8 round with a good point

Paper/support: 300gsm (140lb) NOT watercolour

Other: eraser

Artist's Tip

The artist has used Winsor & Newton artists' watercolours.

To avoid overworking a white flower, paint a background wash first. This will create a contrasting edge and make it easier to simplify the shadow on the flower itself.

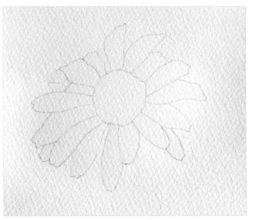

1. Lightly sketch the flower then wet the paper surrounding the pencil edge. Prepare an aureolin wash and paint around the lower petals, cutting swiftly around the edges with the point of the brush and pulling away to the paper edge.

3. Drag out some colour between the petals and along the vein recesses. Now mix a grey with cobalt blue plus a little burnt sienna then use this to add shadow detail to the petals wet-on-dry, leaving the petal edges white against the background to create a crisp contrast. Leave this to dry.

2. While still damp, surround the remaining background area with cobalt blue, letting it run to create a variegated green. Apply new gamboge to the dry flower centre; while this is still damp, stipple on a green mix of new gamboge and cobalt blue.

4. When dry, apply a stronger green mix of new gamboge and cobalt blue to the closest edge of the centre to provide more tonal definition and form, then pull this green outwards from the centre to create depth. Finally add the stem and a suggestion of foliage then erase the pencil lines.

Layering paint to create depth and energy

Lynda Cookson

The dripped and layered paint of this gold-tipped floral technique uses a light, a medium and a dark colour to create a background with depth and energy through which a story and sense of life can be suggested to the viewer. It's a great introduction to abstract techniques for painters who would like to start loosening up their work.

YOU WILL NEED:

Oils: cadmium yellow; cadmium red; French ultramarine blue; sap green

Acrylics: gold

Brushes: No. 18 flat hog hair; Cotman 3mm watercolour

Paper/support: 61 x 50.8cm (24 x 20in) 100% linen stretched canvas

Other: light modelling paste; large, round-tipped palette knife; distilled turpentine; four containers for diluted paint

Artist's Tip

The artist has used Winsor & Newton brushes, Winsor & Newton canvas, Liquitex light modelling paste and Winsor & Newton distilled turpentine.

1. Create your design on the canvas, using a healthy amount of modelling paste on the palette knife so that each petal is formed with only one stroke and stands proud of the canvas. Now using less modelling paste, create more but less-prominent marks on the canvas to add leaves and texture that will catch the paint. Leave to dry.

2. Squeeze a small amount of each paint into a container, then mix each colour with approximately 150ml (5.3floz) of turpentine. Now paint the flowers and leaves with combinations of red, yellow and blue colours using the flat hog brush.

3. Still with the hog brush, paint a wash of yellow behind the flowers, leaving space for a blue wash in the non-textured part of the canvas. Now apply this blue wash, allowing the yellow and blue applications to mix naturally. Leave to dry.

4. Enhance and intensify the background washes if necessary then drop in green paint for the leaves. Finally, with gold acrylic and the 3mm watercolour brush, pick out and highlight selected parts of the flowers and their stamens.

Creating sharp and soft focus effects with a palette knife

Liz Yule

I woke early one morning while on holiday to find the sun breaking through low lying mist, which I thought would make a wonderful watercolour subject. I had used a palette knife and a water spray before to paint ferns, so I knew I could achieve a mixture of sharp and soft focus marks that would be really useful in this situation.

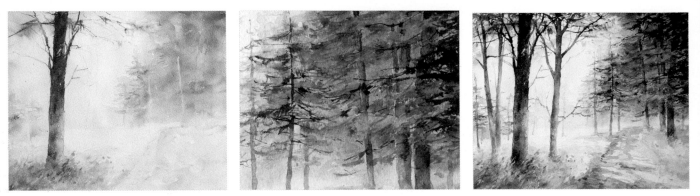

YOU WILL NEED:

Artists' watercolours:
Prussian blue; sepia; raw sienna; light red; Winsor blue (green shade); indigo

Gouache: white

Brushes: Size 6 and 7 squirrels; Kolinsky Size 4 and 6 round sables

Paper/support:
watercolour

Other: palette knife; water spray bottle

1. Dampen the paper then apply washes of Prussian blue, sepia, raw sienna and light red with the Size 7 brush, leaving some areas untouched to represent mist. Leave to dry then paint the distant trees with Prussian blue and sepia wet-in-wet. Next paint the dark foreground tree with indigo at the top then light red and sepia in the lower section; this provides an area of maximum contrast to your background, which allows you to gauge the mid-tones accurately.

2. Again, lightly dampen the paper with the spray then load a palette knife with indigo and drag it across the area at top-right, lightening the knife pressure for fine branches. The paint will float into the droplets of water to create the impression of pine needles.

3. Using light red and sepia, add larger trees to the right-hand side, painting the branches before the trunks. Using the Size 6 squirrel brush for the trunks and a palette knife for the branches, paint three more trees in the foreground. Define the path with shadows and extra detail.

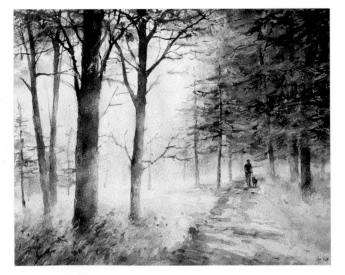

4. Finally use the Size 6 sable to add a figure walking a dog to create a centre of interest at the end of the path. To emphasize the feeling of rising mist, soften some areas of the grass and trunks by applying a light veil of white gouache.

Painting trees in soft focus

Lynn Norris

Gum arabic is a useful medium that reduces the flow of paint in wet-in-wet washes; I use this when I want more control in a wash and it is ideal for hazy distant trees or water reflections. Dragging and dabbing with a natural sponge can quickly create random marks that look really effective; I use these techniques for grasses, distant flowers and foliage.

YOU WILL NEED:

Artists' watercolours:
new gamboge; sap green; permanent rose; cobalt blue; sepia

Brushes: wash brush; No. 10 round; rigger

Paper: 300gsm (140lb) rough watercolour

Other: gum arabic; natural sponge

Artist's Tip

The artist has used Saunders Waterford watercolour paper.

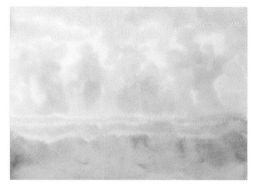

1. Mixing on the paper for bolder colours, apply a wet-in-wet background using washes of new gamboge, sap green, cobalt blue and permanent rose with the wash brush. Leave to dry thoroughly.

2. Next mix sepia with a little water then add equal amounts of gum arabic. Apply water over the area for distant trees then paint them with this mix and the rigger. The gum arabic will reduce the paint flow to create hazy trees. Leave to dry.

3. Now mix a blue-green using sap green and cobalt blue. Slightly dampen the sponge with a little water to ensure it is not too hard; then use its edge to drag a little paint upwards for the stems and leaves of the bluebells.

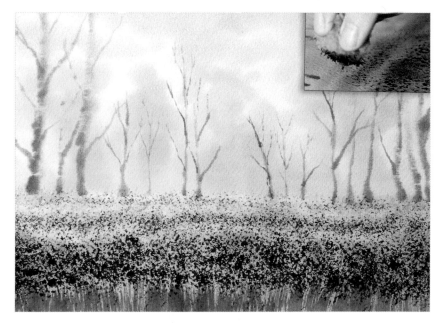

4. Finally mix a violet from permanent rose and cobalt blue. Again using the sponge, gently dab the paint to form the bluebells, making sure the sponge is not too wet and twisting your hand as you dab to achieve a more natural effect. Allow this to dry.

Painting rose petals with oils

Marion Dutton

As a certified floral instructor, I have experimented with and explored many different techniques to capture flowers and flora. Here I demonstrate how to achieve beautiful rose petals in oils using the fascinating wet-in-wet technique. By using loose, overlapping strokes and careful highlights, you can create beautiful and realistic flowers.

YOU WILL NEED:

Artists' oils: alizarin crimson; titanium white; sap green; cadmium yellow

Brushes: ¾in bright; ½in bright; small round

Paper/support: canvas or canvas paper

Other: linseed oil

1. With the ¾in bright brush, cover the rose area with a thin coat of linseed oil. Use the same brush with a thin mix of linseed oil and alizarin crimson to block in the rose with loose, overlapping strokes. Loosely block in some greens with the same brush and a mix of sap green and ultramarine blue, keeping everything loose and soft.

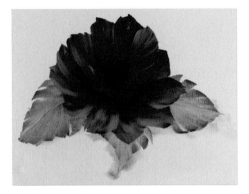

2. Working with the ½in bright brush, now block in some basic leaves using sap green, directing your strokes towards the stem of each leaf. Add very dry (no oil) alizarin crimson to the centre of the rose and fan this out into the direction in which the flower is facing; add this same colour beneath the rose cup.

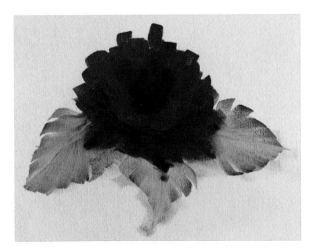

3. Continue using the ½in bright brush to mix titanium white with a touch of alizarin crimson to create a pink. Starting at the top of the rose, apply this mix with overlapping strokes directed towards the centre to create back petals. Use the same technique to paint the skirts of the rose.

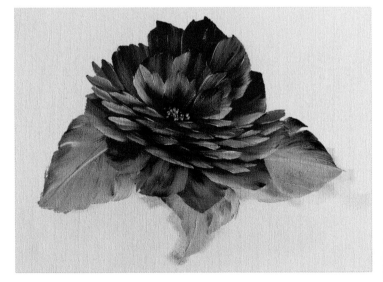

4. Create the foreshortened petals by turning the brush to the side and pulling comma strokes across the rose. Add another row of back petals where needed with the pink. Add brighter highlights to some of the petals using thick titanium white, then highlight the leaves with a touch of cadmium yellow. To complete, use the small round brush to tap in the stamens with cadmium yellow and a small touch of titanium white.

Painting trees upwards and outwards

Paul Hewson

As a teaching artist I try to show beginners a simple way of painting trees. By using simple upstrokes to paint upwards and outwards, you can create realistic and effective trees that will bring depth and interest to your paintings.

YOU WILL NEED:

Watercolours: lemon yellow; cobalt blue; French ultramarine; alizarin crimson

Brushes: Nos 14 and 8 round; rigger

Paper/support: 300gsm (140lb) NOT watercolour

1. Mix lemon yellow and cobalt blue to make a mid green then add French ultramarine and alizarin crimson to make a separate green-brown creamy mix. With simple upstrokes, use the No. 14 round brush and the creamy brown mix to paint the shadow side of the tree.

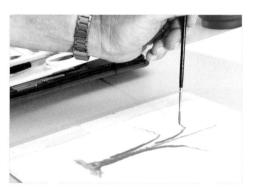

2. Now using a damp No. 8 round brush, tease out the paint from the dark shadow side to the sunlit side of the trunk.

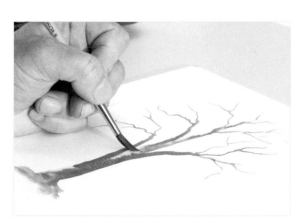

3. Repeat Step 1 using the No. 14 brush and greeny-brown mix then repeat Step 2 using the damp No. 8 brush to create three or four large boughs radiating from the trunk.

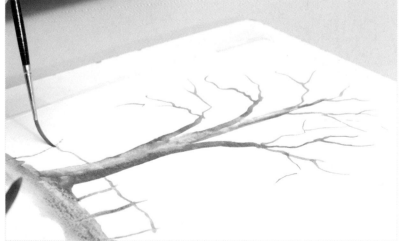

4. Load the No. 2 rigger with the greeny-brown mix then hold it at the end of the handle to paint the smaller branches by pushing the brush into the trunk and painting upwards and outwards, wriggling and releasing the pressure to make the marks finer. Finish by adding twigs along the branches.

Creating realistic trees and foliage

Trudy Friend

To create realistic foliage and trees, you need to introduce detail and depth and build up texture. Inktense pencils create detail when applied dry, but also the versatility of line and wash when used wet.

YOU WILL NEED:

Inktense coloured pencils: mustard; spring green; tan; apple green; baked earth; iron blue; madder brown; charcoal grey; beech green; Indian ink

Brushes: large detailer; worker

Paper/support: 150gsm (72lb) A4 sheet of NOT watercolour

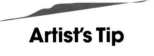

Artist's Tip

The artist has used Derwent Inktense pencils, SAA brushes and Bockingford watercolour paper.

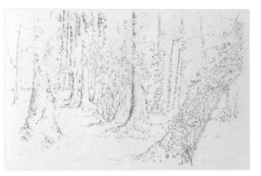

1. Sharpen the Indian ink pencil to a point then start to draw the tree trunks in position, using short strokes to create texture. Leave some gaps through which twigs and small branches will eventually pass and suggest foliage areas with crisscross strokes, leaving plenty of untouched paper.

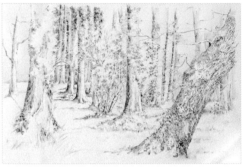

2. Using the large detailer brush dipped in clean water, gently touch your pencil marks to blend the pigment, thus creating a variety of tones. Be careful not to lose too many areas of untouched paper, as your colours will be painted in these.

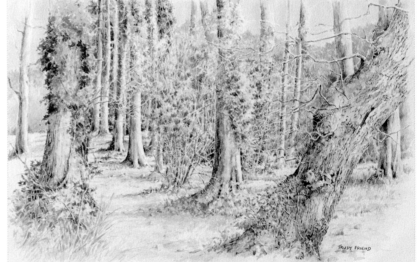

3. Sharpen each coloured pencil strip into separate wells and mix with water; you can now use them as you would watercolour paints. Paint the palest hues first over white paper and into the blended areas that, although 'fixed' when water was first used, may still mix with colour in places.

4. Finally, use the worker brush to work dark hues and tones into the shadow areas to bring the light forms forward, thus emphasizing contrasts. Wash a dilute mix of madder brown and charcoal grey to paint the pathway, creating texture for this surface with short, uneven brushstrokes.

Breaking up dark backgrounds

Rachel McNaughton

For me, colour is always a strong and vibrant feature of my paintings. This technique of breaking up a dark and rich background colour with something bright and pure like a magnolia flower creates that vibrancy, using the strong contrasts of light and dark to great effect.

YOU WILL NEED:

Artists' watercolours: permanent rose; Winsor violet; light red; burnt umber; raw sienna; ultramarine blue; Payne's grey

Pencils/pens: 2B pencil

Brushes: Whopper Size 30 with a good point; Size 10 all-rounder; fine rigger

Paper/support: 300gsm (140lb) NOT watercolour

Other: masking tape; palette with deep wells

Artist's Tip

The artist has used SAA brushes.

1. With the 2B pencil, draw the outline of the magnolia flower, working from the centre. Next fix masking tape around the outside edge of your paper, making sure that some of the petals are 'clipped' by the tape.

2. Mix two creamy liquid washes: Winsor violet with Payne's grey, then Winsor violet with permanent rose. Fill your Size 30 brush with one of these mixes and start to paint the background, working clockwise from the stem and filling each small area of background created by the clipped petals. Vary the colour as you go by alternating between both mixes, using plenty of paint and always working it into a puddle on the paper. Leave to dry.

3. Now mix two thin washes of raw sienna and permanent rose then two dark mixes of burnt umber with ultramarine blue, and Winsor violet with permanent rose. Working on one petal at a time, dampen the paper then drop in the raw sienna wash and then the permanent rose with the Size 10 brush, allowing the background colour to mix into them. Paint the darker petals with the burnt umber and ultramarine blue mix then paint the stem with the Winsor violet and permanent rose mix, also using the Size 10 brush.

4. Mix permanent rose and raw sienna to paint the stamens using the Size 10 brush, suggesting delicate veining with the fine rigger, then leave to dry. Create a blue from ultramarine and light red to paint the shadows and leave to dry. Finally, peel away the masking tape to reveal the crisp edges.

Painting a miniature

Shelia Southwell

This is my favourite technique, as I particularly like the way the paint can be superimposed and stroked over the underlying colours. I developed the idea myself by first painting white daisies, then progressing to more complex subjects. I have found this technique to be very popular with my own students and at club workshops.

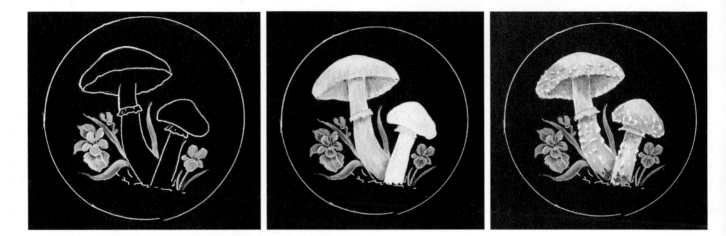

YOU WILL NEED:

Artists' watercolours: sap green; Winsor violet; cadmium yellow; cadmium red; brown umber; Payne's grey; cobalt turquoise (or a mix of any blue green)

Gouache: opaque white

Pencils/pens: white biro; white pencil

Brushes: No. 2 with a fine point; No. 6 round; soft brush for blending colours (a make-up brush is good)

Paper/support: black card or stiff paper

1. First draw or trace the design onto black card – no details, just outlines. Paint the little flowers using violet mixed with a little white gouache then paint their yellow centres, adding a tiny red dot. Now using the No. 2 brush, paint the leaves with mixes of white gouache with sap green, and white gouache with cadmium yellow.

2. Using the No. 6 round brush, paint in the mushrooms with white gouache. Apply turquoise over the top of the white then blend this by stroking with a slightly damp, soft brush. When dry, add yellow to the mushroom caps, keeping the application very light. Now with Payne's grey mixed with white gouache, add shadows under the cap, on the stalk ring and along the stalk.

3. Paint a little additional cobalt turquoise on the stalks in the shadow areas. Using neat white gouache with the small brush, randomly paint the tiny scales on the caps and stalks then make the cap edges ragged and uneven. With Payne's grey, paint shadows under the stalk ring and scales then with brown, paint the scraps of compost around the base of the mushrooms.

4. With the fine pointed No. 2 brush, paint in the gills. To complete the painting, strengthen the shading if necessary, then add a few extra grasses.

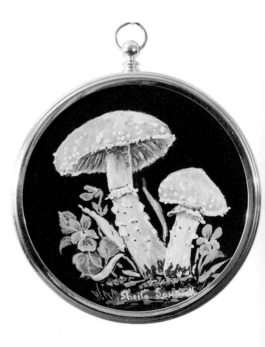

Using a palette knife for rich texture and colour

Sophia Flowers

As a professional artist, I bring enthusiasm and commitment to my creative work. When painting, I step into a world of colour and imagination, creating dynamic works of art that elevate and inspire the viewer. As a qualified instructor, I love sharing my joy of painting through tutoring and I particularly enjoy helping students discover their creativity, especially those who have never painted before.

YOU WILL NEED:

Oils: cadmium yellow; titanium white; cadmium green; cobalt turquoise; cobalt violet; ultramarine violet; sap green

Paper/support: canvas board

Other: palette knife

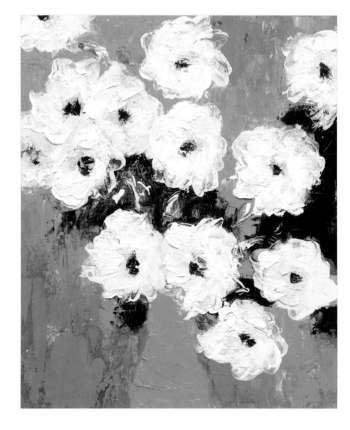

1. Take a roll of green paint onto your palette knife and start creating textural leaves; wiggling and pulling the knife across the canvas then splatting it by lifting it up and down. After you have applied an initial layer of various greens and allowed them to dry, add cadmium yellow on top.

2. Now take rolls of different colours onto the knife and pull them across the canvas to apply various background colours. In some areas indicate foliage without creating definite outlines, allowing the leaves already painted to show through.

3. Completely change the appearance of a flat-looking flower to one filled with vibrancy by taking a roll of cadmium yellow onto the palette knife and shaping it loosely around the centre. Use a deep ultramarine violet on the palette knife to form the centre then leave to dry.

4. Once dry, add further layers of titanium white and additional yellows to build up the texture in the piece. The finished painting should have six layers in total, including leaves, background and flowers.

Painting a dewdrop

Susan Neale

Dewdrops are more simple to paint than they might at first appear, bringing sparkle and a three-dimensional look to your finished painting. Note that they will always reflect the colour of the leaf or petal they are sitting on.

YOU WILL NEED:

Watercolours: lemon yellow; indigo

Gouache: permanent white

Pencils/pens: HB pencil

Brushes: Nos 2 and 7 rounds

Paper/support: 300gsm (140lb) NOT watercolour

1. Use the lemon yellow and indigo to mix a dark green then paint your leaf with the No. 7 brush. Add the veins with white gouache tinted with a little lemon yellow, using the No. 2 brush. When dry, draw a dewdrop then wet this shape.

2. Now use a darker leaf colour and the No. 7 brush to paint the top of the dewdrop to create a shadow area, softening the shape by adding water. Leave to dry.

3. Still with the No. 7 brush, paint the cast shadow at the opposite end of the dewdrop using a darker tone of the leaf colour.

4. To finish, use the permanent white gouache to apply a rounded dot to the top of the dewdrop and a highlight to the bottom end.

Developing natural textures with acrylics

Wendy Jelbert

When painting gardens and landscapes, texture is the key ingredient to make your colours and shapes vibrant and natural. By using texture paste, sand and carefully mixed colours, you can create interest and realistic textures to great effect. Here I also demonstrate an alternative method to create natural texture, this time using acrylics as watercolours.

YOU WILL NEED:

Acrylics: Hooker's green; cadmium yellow; white; burnt sienna; cadmium red; cobalt blue; cerulean blue

Pencils/pens: drawing pencil; ruling drawing pen for masking fluid

Brushes: Size 2 acrylic rigger; No. 5 acrylic flat; No. 8 acrylic

Paper/support: 30.5 x 41cm (12 x 16in) minimum 300gsm (140lb) watercolour or acrylic

Other: drawing board; texture paste in tube, small jar or pot; natural sand, or similar; palette; palette knife; masking fluid

1. Secure your paper to the drawing board then draw in the main features, concentrating on their various different angles. Then apply texture paste with the knife for the steps and front pot – this will be painted over when completely dry, so apply the paste to create a rich impasto like surface. Add the natural sand to the steps and pots to create a natural weathered feel.

2. Mix some cadmium red and cadmium yellow to create an apricot colour then apply this lightly all over the drawing. Using cadmium yellow first, then adding Hooker's green alongside, paint a natural flowing background. Then mix burnt sienna and cobalt and start to paint in the arch's construction, allowing glimpses of the original background colour to show through.

3. With mixes of Hooker's green, cerulean blue and cobalt blue, dab in small markings to indicate the many varieties of foliage. Apply dots of red and orange with the rigger for the roses, and various mixes for the small watering cans, birdhouse, and pots. For the steps, apply burnt sienna, white and cadmium yellow with the No. 8 brush. Add more yellow to this mix to complete the foreground then apply thicker burnt sienna with the No. 5 brush for the paving markings

4. In this alternative completed painting, use acrylics as watercolours. Apply masking fluid to create the many foliage textures, painting their feathery, spikey and fine, swirly lines. Wait until thoroughly dry then add watery acrylics in wet-in-wet washes.

Index of contributors

The publisher would like to thank the contributors whose projects and paintings have been featured in this book. Please see the individual artist's website for more information about their work and how to contact them.

Acraman, Paul
www.paulacramanartist.co.uk

Adlington, Gill
www.saa.co.uk/art/gilladlington

Agan, Cindy
www.cindyaganart.com

Allen, Denise
www.deniseallen.co.uk

Allis, Marilyn
www.marilynallis.co.uk

Apps, Paul
www.paulappsfineart.com

Bays, Jill
www.jillbays.com

Bearcroft, Vic
www.vicbearcroft.co.uk

Beattie, Paul
www.paulbeattieart.com

Bezzina, Charles
www.charlesbezzina.com

Board, Alison
www.alisoncboard-fineart.co.uk

Booth, Grahame
www.grahamebooth.com

Bougourd, Louise
www.louisebougourd.co.uk

Bradley, Colin
www.colinbradleyart.co.uk

Burrow, Deborah
www.deboraheileenburrow.co.uk

Cambridge, Melanie
www.melaniecambridge.com

Cartwright, Sue
www.suecartwright.co.uk

Castell, Lynne
www.lynnecastell.f2s.com

Champion, Judith
www.championart.org.uk

Chipp, Terry
www.terrychipp.co.uk

Cilmi, Monika
www.monikacilmi.com

Cockrean, Ali
www.alicockrean.co.uk

Cookson, Lynda
www.lyndacookson.thepainterspalette.ie

Corduban, Irina
www.irinacorduban.wix.com/art-and-tuition

Coupe, Sean
www.imagineartsonline.co.uk

Cowell, Dee
www.saa.co.uk/art/deecowell

Cox, Graham
www.moodyviews.co.uk

Cudmore, Malcolm
www.blog.malcolm-cudmore.com

Darby, Yvonne
www.yvonnemariedarby.com

De Mendonca, Rebecca
www.rebeccademendonca.co.uk

Deighton, Sue
www.suedeightonartist.co.uk

Dutton, Marion
www.mazartstudio.co.uk

Evans, Charles
www.charlesevansart.com

Evans, Margaret
www.shinafoot.co.uk

Fenwick, Keith
www.keithfenwick.co.uk

Flowers, Sophia
www.joyfulpainting.co.uk

Ford, Jeremy
www.jeremyford.co.uk

Friend, Trudy
www.trudyfriend.co.uk

Gardner, Jan
www.jangardner.com

Geeson, Andrew
www.andrewgeesonartist.com

Good, Jayne
www.paintwithjayne.co.uk

Goodall, Alan
www.alangoodall-art.co.uk

Greene, Gary
www.ggart.biz

Hall, Steve
www.stevehallartist.co.uk

Hamer, Lavinia
www.saa.co.uk/art/laviniahamer

Hammond, Lee
www.leehammond.com

Hargreaves, Alison
www.alisart.co.uk

Hewson, Paul
www.paulhewsonart.co.uk

Herniman, Barry
www.barryherniman.com

Higton, Steve
www.shigtonart.co.uk

Holland, Richard
www.richardhollandlandscapeartist.co.uk

Hughes, Bob
www.bobhughesartist.com

Hurst, Sharon
www.sharonhurst.co.uk

Hyde, David
www.davidhyde.org.uk

Jones, Howard
www.howardjonesart.co.uk

Kemp, Linda
www.lindakemp.com

King, Julie
www.juliehking.co.uk

Ince, Murray
www.murrayince.com

Inglis, Cath
www.cathinglis.com

Jelbert, Wendy
www.wendyjelbert.co.uk

Kaminsky, Helen
www.helenkaminsky.co.uk

Kersey, Geoff
www.geoffkersey.co.uk

Kingwell, Alan
www.alankingwell.co.uk

Knight, Paul
www.saa.co.uk/art/astarvinartist

Lang, Roy
www.roylangartist.com

Lowrey, Arnold
www.lowrey.co.uk

McNaughton, Rachel
www.artbyrachel.co.uk

Macleod, Katherine
www.societyink.co.uk

Massey, Carole
www.carolemassey.com

Matthews, Linda
www.broadskiesgallery.co.uk

Nash, Julie
www.lickychickstudio.co.uk

Neale, Susan
www.thehayloftstudio.com

Nice, Claudia
www.brightwoodstudio.com

Norris, Lynn
www.freewebs.com/lynnnorrisart

Norton, Betty
www.bettynorton.co.uk

Olsson, Celia
www.celiaolssonartist.co.uk

Palmer, Matthew
www.mattartist.co.uk

Parmenter, Kaye
www.kayeparmenter.co.uk

Patey, Geraldine
www.saa.co.uk/art/geraldinesp

Petrie, Jacqui
www.jacquipetrie.co.uk

Pitcher, Linda
www.lindapitcher.co.uk

Riggs, Clive
www.cliveriggs-fineart.co.uk

Sareen, Sue
www.sareenarts.com

Scarfe, Fraser
www.fraserscarfe.co.uk

Scott, Gwen
www.gwenscottwatercolours.co.uk

Sealey, Warren
www.warrensealey.com

Skidmore, Mike
www.mikeskidmoreonline.com

Somerscales, John
www.jdsomerscales.co.uk

Southwell, Sheila
www.sheilasouthwell.com

Summers, Haidee-Jo
www.haideejo.com

Talbott-Greaves, Paul
www.talbot-greaves.co.uk

Teeuw, Mo
www.moteeuw.co.uk

Terrington-Wright, Sean
www.seantwright.com

Townsend, Sue
www.suetownsendart.co.uk

Warner, Claire
www.saa.co.uk/art/claire

Webb, David
www.davidwebbart.co.uk

Wellman, Gregory
www.gregorywellman.com

White, Carol
www.carolsartonline.co.uk

Williams, Steve
www.saa.co.uk/art/stevewilliamsart

Woolley, Peter
www.peterwoolley.co.uk

Yule, Liz
www.lizyule.com

Index

A DAVID & CHARLES BOOK
© F&W Media International, Ltd 2014

David & Charles is an imprint of F&W Media International, Ltd
Brunel House, Forde Close, Newton Abbot, TQ12 4PU, UK

F&W Media International, Ltd is a subsidiary of F+W Media, Inc
10151 Carver Road, Suite #200, Blue Ash, OH 45242, USA

Text and Designs © SAA 2014
Layout © F&W Media International, Ltd 2014

First published in the UK and USA in 2014

A catalogue record for this book is available from the British Library.

ISBN-13: 978-1-4463-0380-1 paperback
ISBN-10: 1-4463-0380-2 paperback

Printed in China by RR Donnelley for:
F&W Media International, Ltd
Brunel House, Forde Close, Newton Abbot, TQ12 4PU, UK

10 9 8 7 6 5 4 3 2 1

Acquisitions Editor: Verity Graves-Morris
Desk Editors: Hannah Kelly/Emma Gardner
Project Editor: Freya Dangerfield
Junior Art Editor: Jodie Lystor
Designers: Jennifer Stanley/Sue Cleave
Production Controller: Kelly Smith

F+W Media publishes high quality books on a wide range of subjects.
For more great book ideas visit: www.stitchcraftcreate.co.uk